RARITAN PUBLIC LIBRARY 54 E. SOMERSET STREET RARITAN, NJ 08869 908-725-0413 7/11

4 · * *···			
11.7			

Pablo

Picasso

1881 - 1914

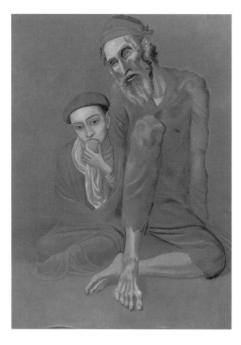

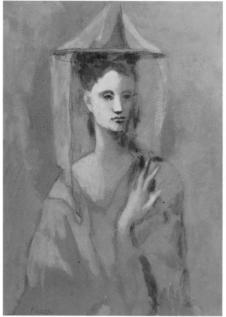

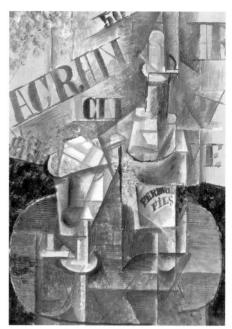

Cover: Stéphanie Angoh Page layout: Julien Depaulis

© Confidential Concepts, worldwide, USA, 2004

© Sirrocco, London, 2004 (English version)

© 2004 Picasso Estate/Artists Rights Society, New York

Published in 2004 by Grange Books an imprint of Grange Books Plc The Grange Kingsnorth Industrial Estate Hoo, nr Rochester Kent ME3 9ND www.Grangebooks.co.uk ISBN 1-84013-556-5 Printed in China

All rights reserved. No part of this publication may be reproduced or adapted without the permission of the copyright holder, throughout the world. Unless otherwise specified, copyright on the works reproduced lies with the respective photographers. Despite intensive research, it has not always been possible to establish copyright ownership. Where this is the case we would appreciate notification.

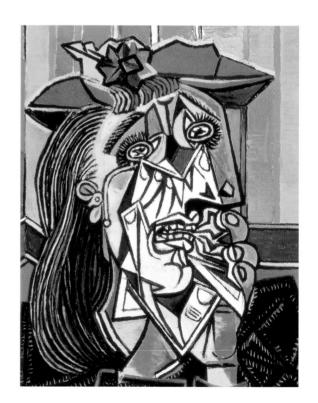

Pablo

Picasso

1881 - 1914

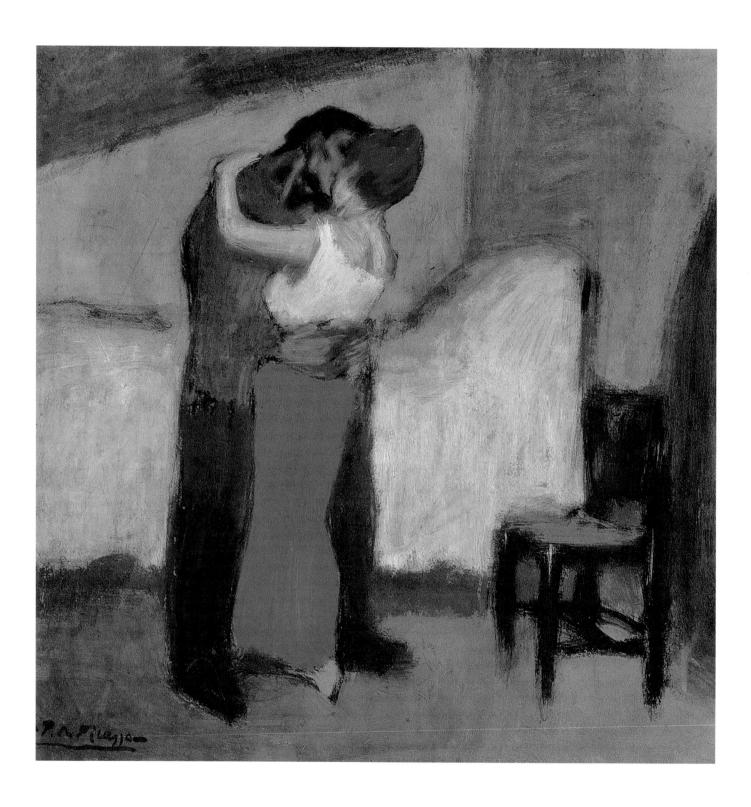

From childhood to Cubism

he works of Picasso published in the present volume cover those early periods which, based on considerations of style, have been classified as Steinlenian (or Lautrecian), Stained Glass, Blue, Circus, Rose, Classic, «African», Proto-Cubist, Cubist... From the viewpoint of the "science of man", these periods correspond to the years 1900-1914, when Picasso was between nineteen and thirty-three, the time which saw the formation and flowering of his unique personality.

But a scientific approach to Picasso's œuvre has long been in use: his work has been divided into periods, explained both by creative contacts and reflections of biographical events. If Picasso's work has for us the general significance of universal human experience, this is due to the fact that it expresses, with the most exhaustive completeness, man's internal life and all the laws of its development. Only by approaching his œuvre in this way can we hope to understand its rules, the logic of its evolution, the transition from one putative period to another.

Picasso was born a Spaniard and, so they say, began to draw before he could speak. As an infant he was instinctively attracted to the artist's tools. In early childhood he could spend hours tracing his first pictures in the sand. This early self-expression held the promise of a rare gift.

Málaga must be mentioned, for it was there, on 25 October 1881, that Pablo Ruiz Picasso was born and there that he spent the first ten years of his life. Málaga was the cradle of his spirit, the land of his childhood, the soil in which many of the themes and images of his mature work are rooted. He first saw a picture of Hercules in Málaga's municipal museum, witnessed bullfights on the Plaza de Toros, and at home watched the cooing doves that served as models for his father. The young Pablo drew all of this and by the age of eight took up brush and oils to paint a bullfight. As for school, Pablo hated it from the first day and opposed it furiously.

In 1891, financial difficulties forced the Ruiz Picasso family to move to La Coruña, where Pablo's father was offered a position as teacher of drawing and painting in a secondary school. La Coruña had a School of Fine Arts. There the young Pablo Ruiz began his systematic studies of drawing and with prodigious speed completed (by the age of thirteen!) the academic Plaster Cast and Nature Drawing Classes.

1. *The Embrace*, 1900. Oil on cardboard, 52 x 56 cm. The Pushkin Museum of Fine Arts, Moscow.

What strikes one most in his works from this time is not so much the phenomenal accuracy and exactitude of execution as what the young artist introduced into this frankly boring material: a treatment of light and shade that transformed the plaster torsos, hands and feet into living images of bodily perfection overflowing with poetic mystery. He did not, however, limit his drawing to the classroom; he drew at home, all the time, using whatever subject matter was out hand: portraits of the family, genre scenes, romantic subjects, animals. In keeping with the times, he "published" his own journals – *La Coruña* and *Azul y Blanco* (*Blue and White*) – writing them by hand and illustrating them with cartoons. At home, under his father's tutelage during his last year in La Coruña, Pablo began to paint live models in oils (see *Portrait of an Old Man* and *Beggar in a Cap*). These portraits and figures speak not only of the early maturity of the thirteen-year-old painter, but also of the purely Spanish nature of his gift: a preoccupation with human beings, whom he treated with profound seriousness and strict realism, uncovering the monolithic and "cubic" character of these images.

That is the way in which Picasso expressed how much his work was intertwined with his life; he also used the word "diary" with reference to his work. D.-H. Kahnweiler, who knew Picasso for over sixty-five years, wrote: "It is true that I have described his œuvre as "fanatically autobiographical". That is the same as saying that he depended only on himself, on his Erlebnis. He was always free, owing nothing to anyone but himself."1 Indeed, everything convincingly shows that if Picasso depended on anything at all in his art, it was the constant need to express his inner state with the utmost fullness. One may compare Picasso's œuvre with therapy; one may, as Kahnweiler did. regard Picasso as a Romantic artist. Let it also be noted that Picasso looked upon his art in a somewhat impersonal manner, took pleasure in the thought that the works, which he dated meticulously and helped scholars to catalogue, could serve as material for some future science. Kahnweiler testifies that in his old age Picasso spoke with greater approval of these early paintings than of those done in Barcelona, where the Ruiz Picasso family moved in the autumn of 1895 and where Pablo immediately enrolled as a student of painting in the School of Fine Arts called La Lonja. So as not to upset his father, Picasso spent two more years in there, during which time he could not but fall, albeit temporarily, under the deadening influence of academism, inculcated by the official school along with certain professional skills. "... I hate the period of my training at Barcelona," Picasso confessed to Kahnweiler.2 However, the studio which his father rented for him, and which gave him a certain

freedom from both school and the stifling atmosphere of family relations, was a real

support for his independence.

 Le Moulin de la Galette, 1900.
 Oil on canvas, 90.2 x 117 cm.
 The Salomon R.Guggenheim Museum, Justin K.
 Thannhauser Foundation, New York.

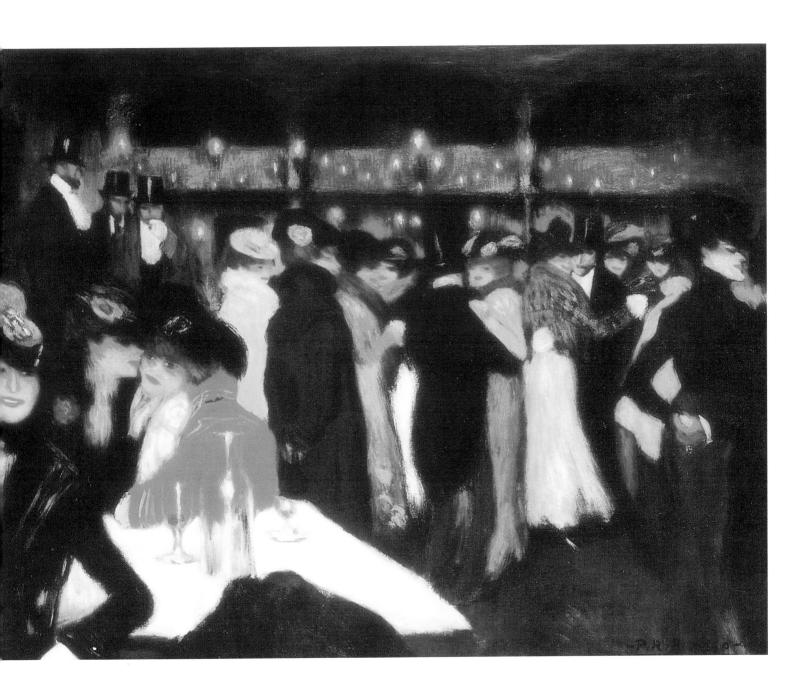

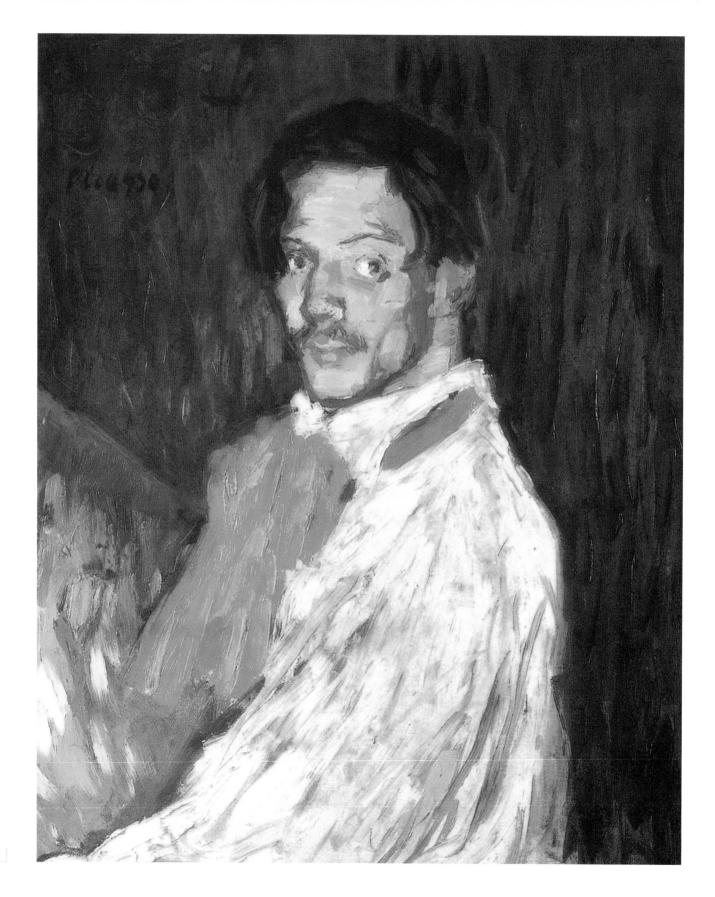

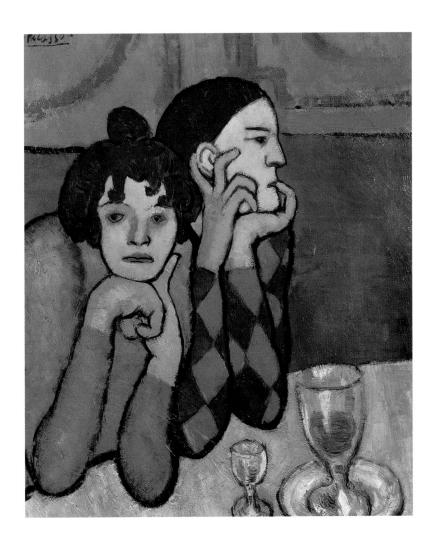

It was here that Picasso summarized the achievements of his school years by executing his first large canvases: *The First Communion* (winter of 1895-1896) and *Science and Charity* (beginning of 1897). The latter received honourable mention at the national exhibition of fine arts in Madrid and was later awarded a gold medal at an exhibition in Málaga. His departure from home for Madrid in the autumn of 1897, supposedly to continue his formal education at the Royal Academy of San Fernando, in fact ushered in the period of post-study years – his years of wandering. Pablo Picasso's wander-years consisted of several phases within a seven year period, from his initial departure to Madrid in 1897, to his final settling in Paris, artistic capital of the world, in the spring of 1904.

To Picasso, Madrid meant first and foremost the Prado Museum, which he frequented more often than the Royal Academy of San Fernando in order to copy the Old Masters (he was particularly attracted by Velazquez).

- 3. *Self-Portrait*, 1901. Oil on canvas, 73.5 x 60.5 cm. Private collection.
- 4. Harlequin and his Companion, 1901.
 Oil on canvas,
 73 x 60 cm.
 The Pushkin Museum of Fine Arts, Moscow.

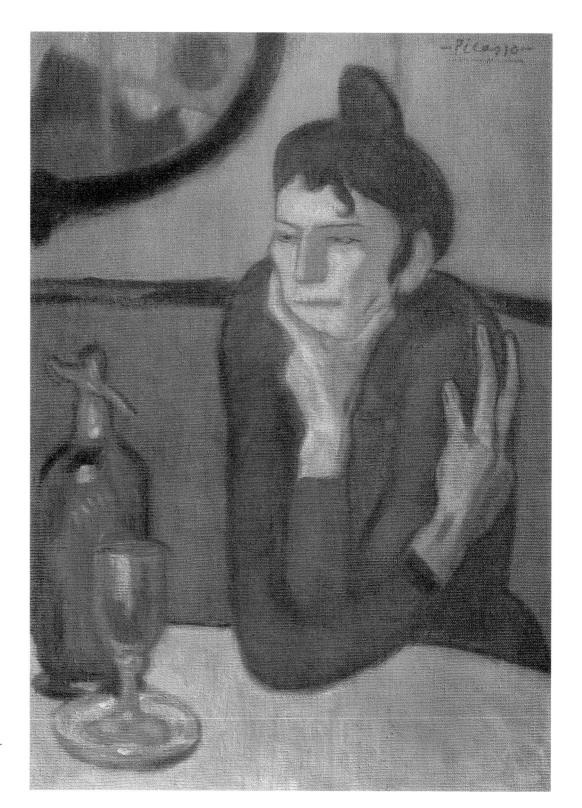

- 5. The Absinthe Drinker, 1901.
 Oil on canvas, 73 x 54 cm.
 The Hermitage, St. Petersburg.
- 6. The Absinthe
 Drinker, 1901.
 Oil on cardboard,
 65.5 x 50.8 cm.
 Melville Hall
 Collection, New York.

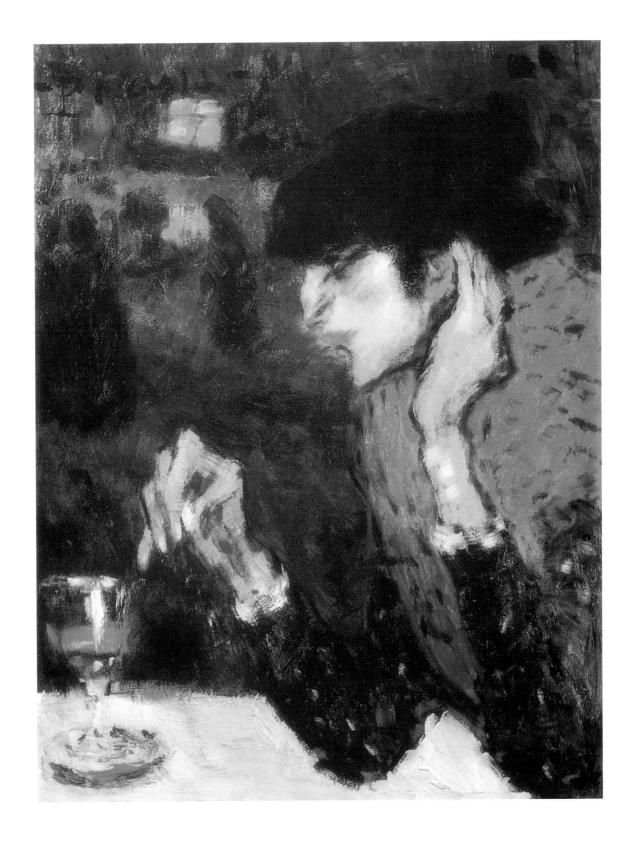

It might be said that the most important events for Picasso in the Spanish capital were the harsh winter of 1897-1898 and the subsequent illness that symbolically marked the end of his «academic career». In contrast, the time spent at Horta de Ebro - a village in the mountainous area of Catalonia, where he went to convalesce and where he remained for eight long months (until the spring of 1899) - was of such significance for Picasso that even decades later he would invariably repeat: "All that I know, I learnt in Horta de Ebro." The months spent in this village were significant not so much in the sense of artistic production as for their key role in the young Picasso's creative biography, with its long process of maturing.

After his first stay at Horta de Ebro, a matured and renewed Picasso returned to Barcelona, which he now saw in a new light: as a centre of progressive trends, as a city open to modern ideas. Indeed, Barcelona's modernism served to give the young Picasso an avant-garde education and to liberate his artistic thinking from classroom clichés. But this avant-garde universe was also merely the arena for his coming-to-be. Picasso, who in 1906 compared himself with a tenor who reaches a note higher than the one written in the score, was never the slave of what attracted him; in fact, Picasso invariably begins where influence ends.

During those Barcelona years, as if caught up in a frenzy of graphic inspiration, Picasso drew a wealth of caricature portraits of his avant-garde friends.

During 1899 and 1900 the only subjects Picasso deemed worthy of painting were those which reflected the "final truth": the transience of human life and the inevitability of death. Bidding the deceased farewell, a vigil by the coffin, a cripple's agony on a hospital bed, a scene in a "death room" or near a dying woman's bed. Finally he executed a large composition called *The Last Moments*, which was shown in Barcelona at the beginning of 1900 and later that same year in Paris at the Exposition Universelle. Picasso then re-used the canvas for his famous Blue Period painting *Life* (p.23)(the earlier work was only recently discovered thanks to X-ray examination). He passed too rapidly through modernism and, having exhausted it, found himself at a dead-end, without a future. It was Paris that saved him, and after only two seasons

dead-end, without a future. It was Paris that saved him, and after only two seasons there he wrote to his French friend Max Jacob in the summer of 1902 about how isolated he had felt in Barcelona among his friends who wrote "very bad books" and painted "idiotic pictures". Picasso arrived in Paris in October 1900. He moved into a studio in Montmartre, where he remained until the end of the year. Although his contacts were limited to the Spanish colony, and even though he involuntarily looked at his surroundings with the eyes of a highly curious foreigner, Picasso immediately and without hesitation found his subject, becoming a painter of Montmartre.

7. *The Burial of Casagemas*, 1901.
Oil on wood,
27 x 35 cm. Musée
Picasso, Paris.

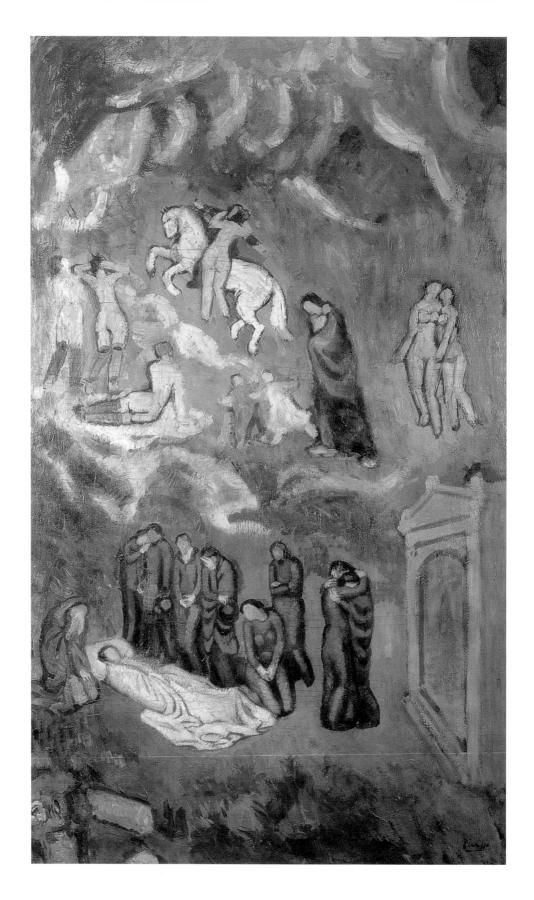

8. The Burial of Casagemas (Evocation), 1901.
Oil on canvas, 146 x 89 cm.
Petit Palais, Paris.

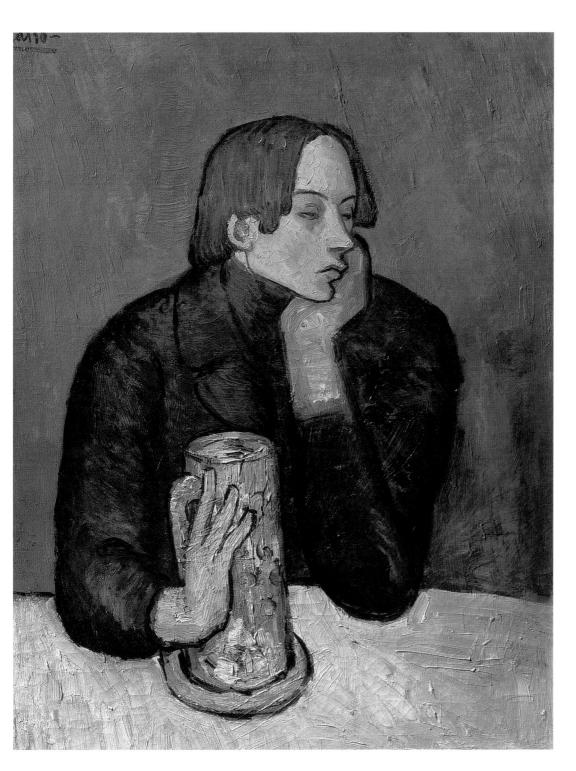

9. Portrait of the Poet Sabartés (The Glass of Beer), 1901. Oil on canvas, 82 x 66 cm. The Pushkin Museum of Fine Arts, Moscow.

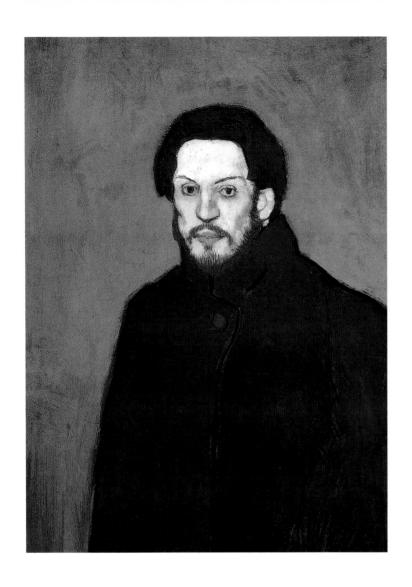

10. *Self-Portrait*, 1901. Oil on canvas, 81 x 60 cm, Musée Picasso, Paris.

A joint letter by Picasso and his inseparable friend, the artist and poet Carlos Casagemas, bears the date of his nineteenth birthday (25 October 1900). Written a few days after Pablo's arrival in Paris, it records their Parisian life; the pair inform a friend in Barcelona of their intensive work, of their intention to exhibit paintings at the Salon and in Spain, of their going to café-concerts and theatres in the evening; they describe their new acquaintances, their leisure activities, their studio. The letter exudes high spirits and reflects their intoxicating delight with life: "If you see Opisso, tell him to come, since it's good for saving the soul - tell him to send Gaudí and the Sagrada Familia to hell... Here there are real teachers everywhere."

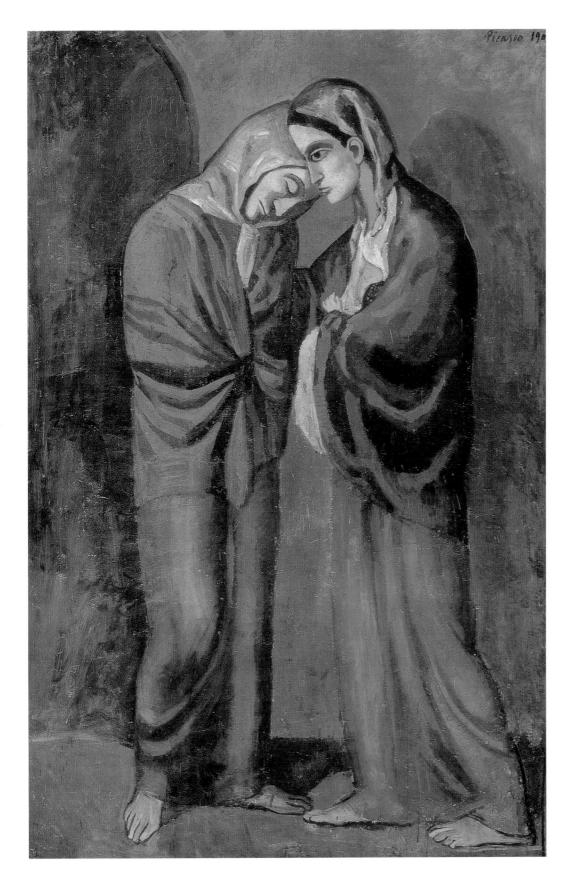

11. *The Visit (Two Sisters)*, 1902. Oil on wood, 152 x100 cm. The Hermitage, St. Petersburg.

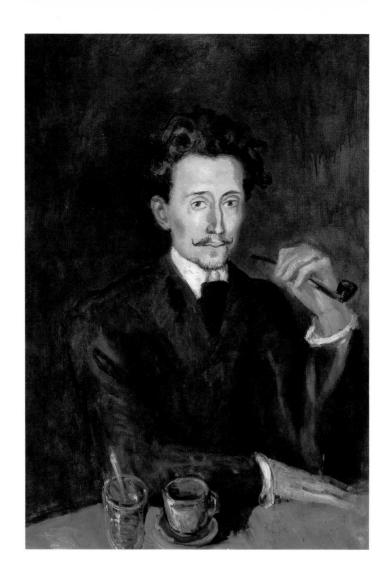

Spanish section was: Pablo Ruiz Picasso, *Les Demiers Moments*), the retrospective Centennale and Décennale de l'Art Français, great shows with paintings by Ingres and Delacroix, Courbet and the Impressionists, up to and including Cézanne; the gigantic Louvre with its endless halls of masterpieces and sculptures of ancient civilizations; whole streets of galleries and shops showing and dealing in new-style painting... He was staggered by the abundance of artistic impressions, by this new feeling of freedom. Picasso's "real teachers" were nonetheless the older painters of Montmartre, who helped him discover the broad spectrum of local subject matter: the popular dances, the café-concerts with their stars, the attractive and sinister world of nocturnal joys,

Vast exhibition halls of paintings at the Exposition Universelle (number 79 in the

12. *Portrait of Soler*, 1903. Oil on canvas, 100 x 70 cm. The Hermitage, St. Petersburg.

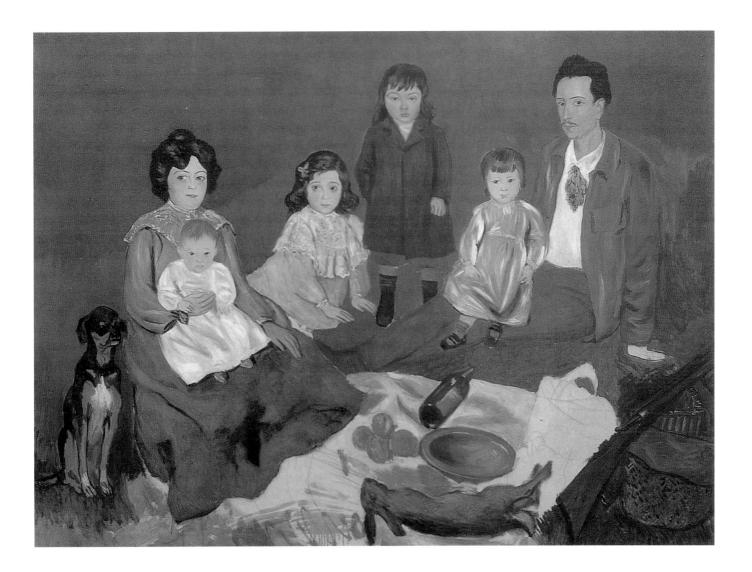

electrified by the glow of feminine charms, but also the everyday melancholy and nostalgic atmosphere of small streets on the city outskirts.

Picasso entered then his so-called Cabaret Period. This subject matter attracted him because it afforded the possibility to express the view that life is a drama and that its heart is the sexual urge. And yet the direct, expressive and austerely realistic treatment of these subjects reminds one not so much of French influences as of Goya's late period.

The artist's sudden departure from Paris in December 1900 looks like a flight. His friend Casagemas shot himself in a café on the Boulevard de Clichy, after returning to Paris despite Picasso's attempts to help him find a measure of peace under the Spanish sun.

13. *The Soler's*, 1903. Oil on canvas, 150 x 200 cm. Musée d'Art Moderne et d'Art Contemporain, Liège.

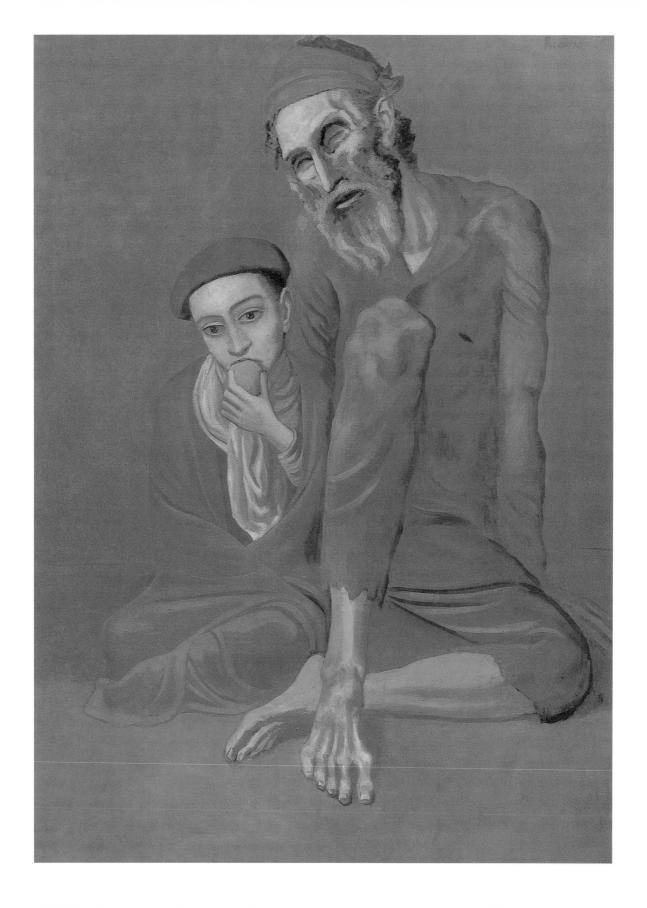

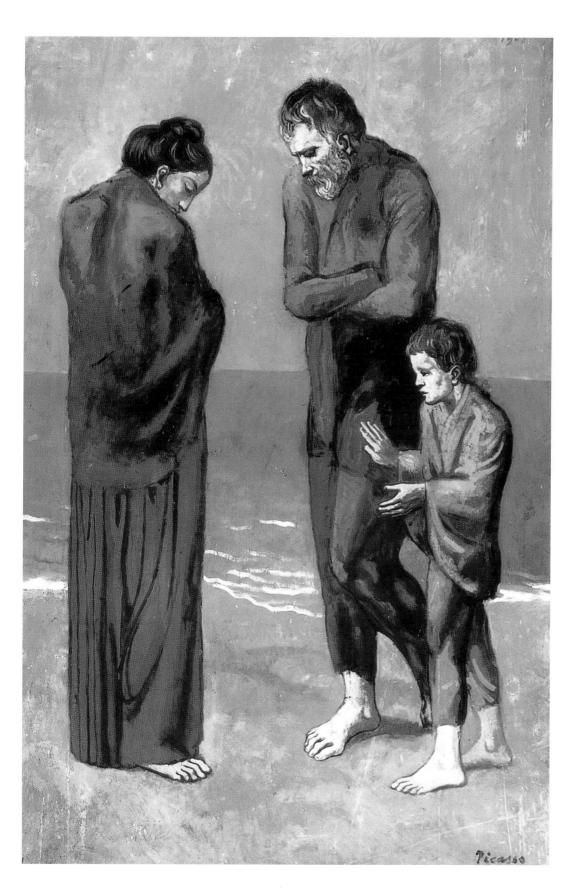

- 14. *Old Jew and a Boy*, 1903. Oil on canvas, 125 x 92 cm. The Pushkin Museum of Fine Arts, Moscow.
- 15. Poor people on the Seashore (The Tragedy), 1903.
 Oil on wood, 105.4 x 69 cm.
 National Gallery of Art, Chester Dale Collection, Washington.

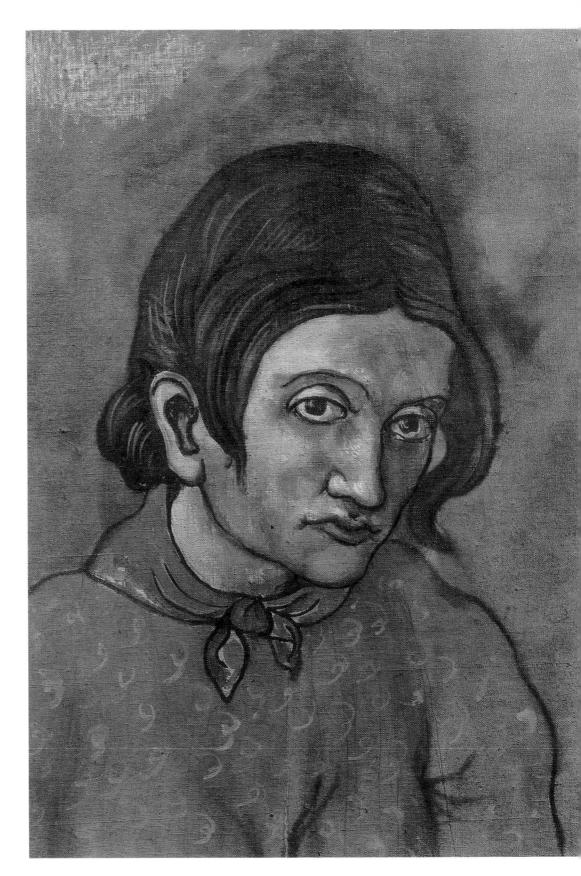

16. Head of a Woman with a Scarf, 1903.
Oil on canvas pasted on cardboard, 50 x 36.5 cm.
The Hermitage, St. Petersburg.

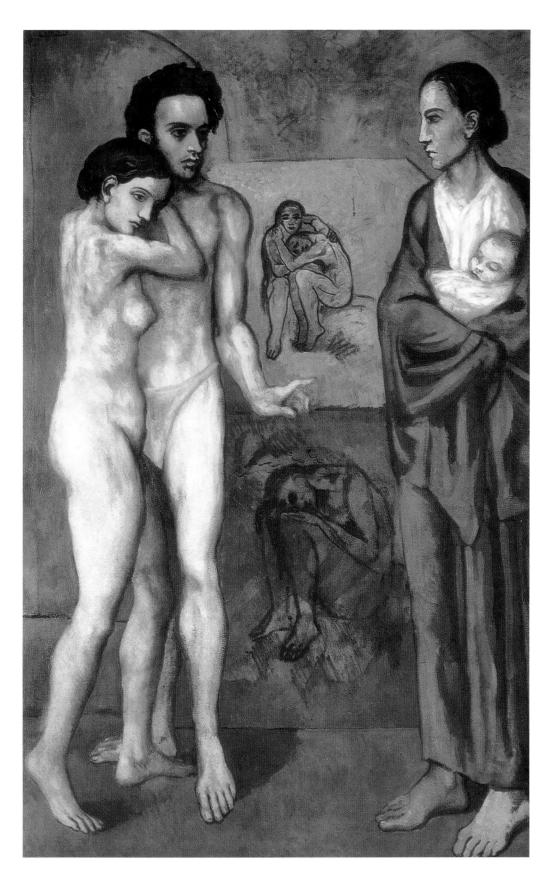

17. *Life*, 1903.
Oil on canvas,
196.5 x 128.5 cm.
The Cleveland
Museum of Art,
Cleveland.

Back in Madrid, Picasso undertook the publication of a magazine called *Arte Joven* (*Young Art*). He also painted society scenes and female portraits. Daix believes that Casagemas's suicide was no small influence. This short "Society" Period (to a certain extent, a young artist's reaction to the temptations of public recognition) ran itself out by the spring of 1901 when, after a stay in Barcelona, Picasso returned to Paris. An exhibition of his works was planned in the gallery of the well-known dealer Ambroise Vollard. Throughout May and the first half of June 1901, Picasso worked very hard, on some days producing two or even three paintings. He "had begun where he had broken off six months before" He used the Impressionist freedom of sinuous brushstrokes, the Japanese precision of Degas's compositions and Toulouse-Lautrec's posters, the heightened, exalted vividness of Van Gogh's colours, heralding the coming of Fauvism, which manifested itself fully only in 1905. But Picasso's so-called pre-Fauvism of the spring of 1901 was of a purely aesthetic, rather than of a subjective, psychological nature.

Picasso exhibited over sixty-five paintings and drawings at the Vollard exhibition that opened on 24 June. Some had been brought from Spain, but the overwhelming majority were done in Paris. Jarring, often shocking subjects, spontaneous, insistent brushwork, nervous, frenzied colours typify the so-called Vollard style. But even though the exhibition was a financial success, many of the pre-Fauve Vollard-style paintings would be painted over in the very near future.

Two canvases dating from this period, *Harlequin and His Companion (p.9)* and *The Absinthe Drinker (p.10)*, deal with one of the early Picasso's favourite subjects: people in cafés. From the viewpoint of style they are sometimes characterized as examples of the so-called Stained-Glass Period (because of the powerful, flexible dark line dividing the major colour planes, typical of work of that period). This style of painting had close aesthetic ties with the Art Nouveau (it derives from Gauguin's Cloisonnism and the arabesques of Toulouse-Lautrec's posters - styles Picasso rated highly at that time); here, however, it is a poetic testament to the predominance of the intellectual principle in Picasso's work.

In formal terms, *Harlequin and His Companion* and *The Absinthe Drinker* continue Gauguin's line, but emotionally and ideologically, they follow Van Gogh, who perceived his *Night Café* as a horrible place, "a place where one can perish, go insane, commit a crime." Generally speaking, one sees here the predominance of form in the composition and the sentimental themes that Daix defined as two of the three essentials of the new style ripening in Picasso throughout the second half of 1901. The third -the use of monochromatic blue -gave this new style its name: the Blue Period. It came into its own late in 1901 and lasted until the end of 1904.

18. *Celestina*, 1904. Oil on canvas, 81 x 60 cm. Musée Picasso, Paris.

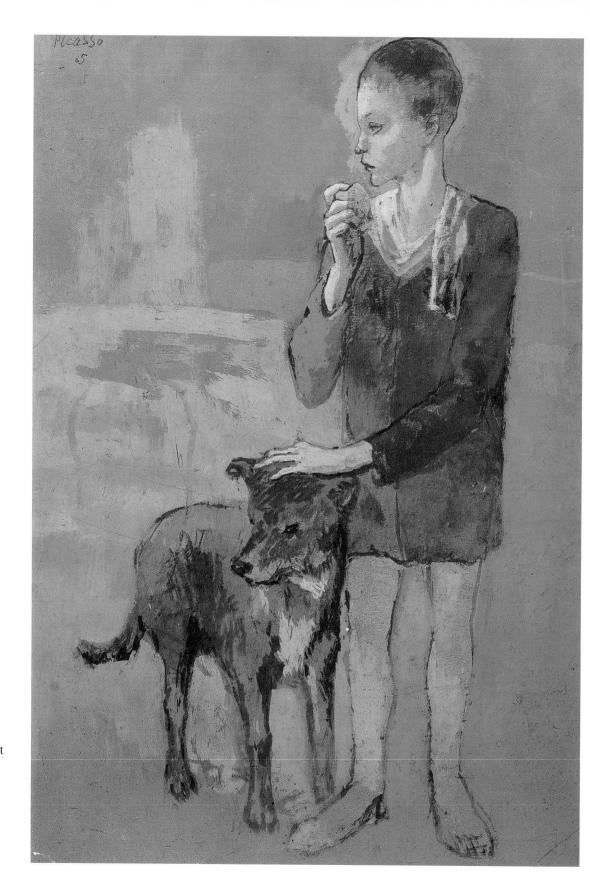

- 19. *Boy with a Dog*, 1905. Gouache on cardboard, 57.2 x 41.2 cm. The Hermitage, St. Petersburg.
- 20. *Tumblers* (Mother and Son), 1905.
 Gouache on canvas, 90 x 71 cm. Stuttgart Staatsgalerie, Stuttgart.

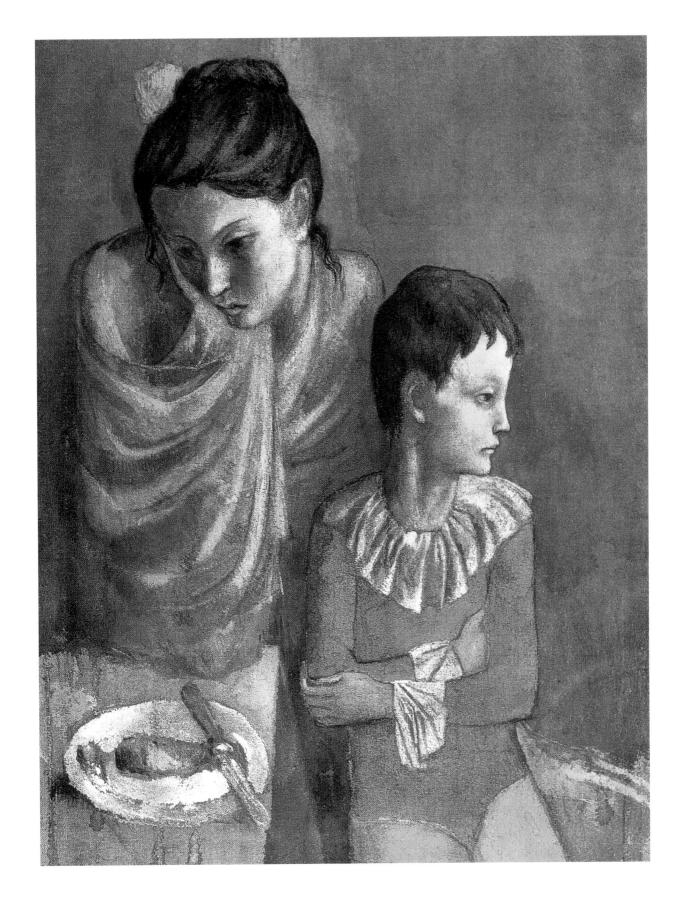

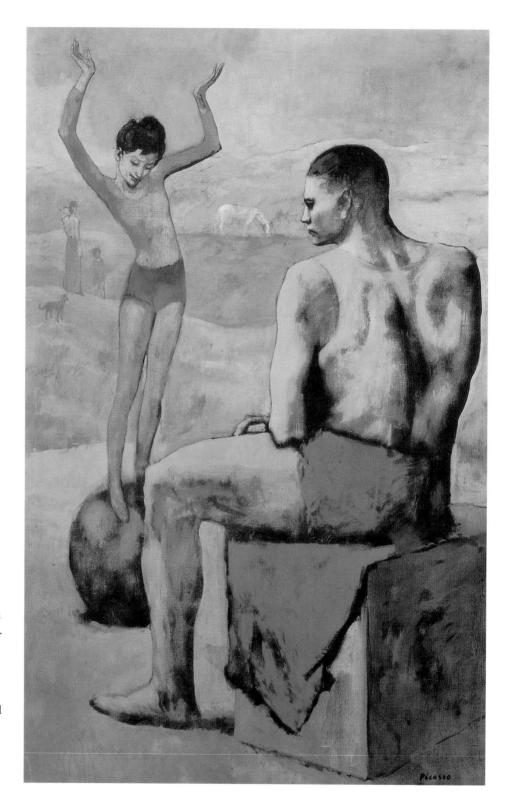

21. Young Acrobat on a Ball, 1905. Oil on canvas, 147 x 95 cm. The Pushkin Museum of Fine Arts, Moscow.

22. Family of Saltimbanques (Comedians), 1905. Gouache and charcoal on cardboard, 51.2 x 61.2 cm. The Hermitage, St. Petersburg.

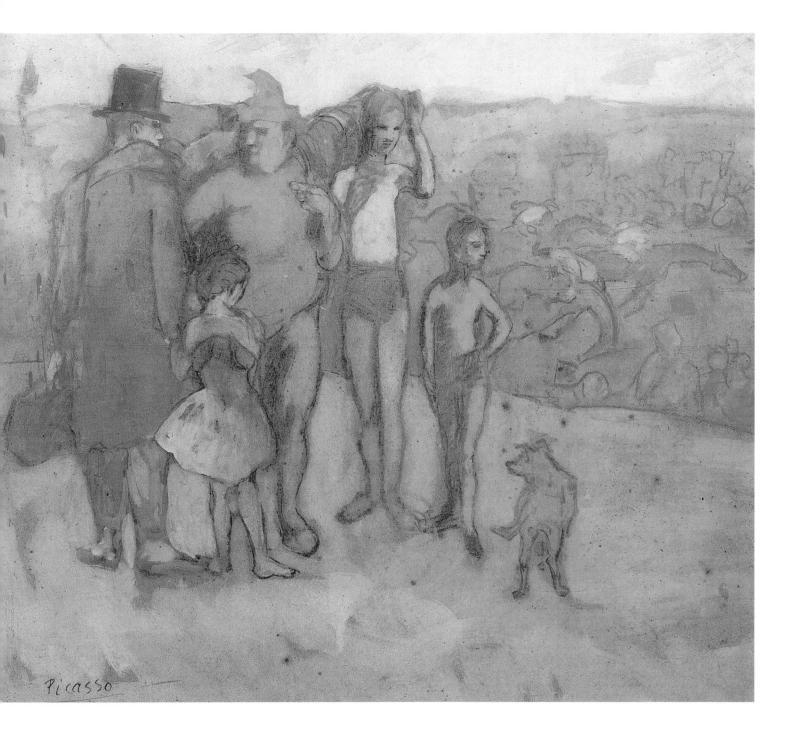

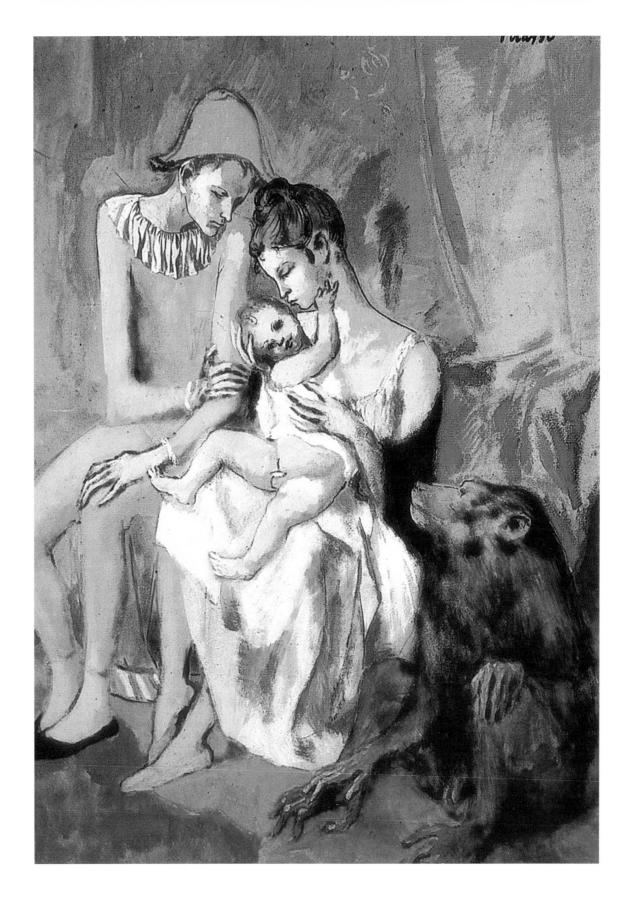

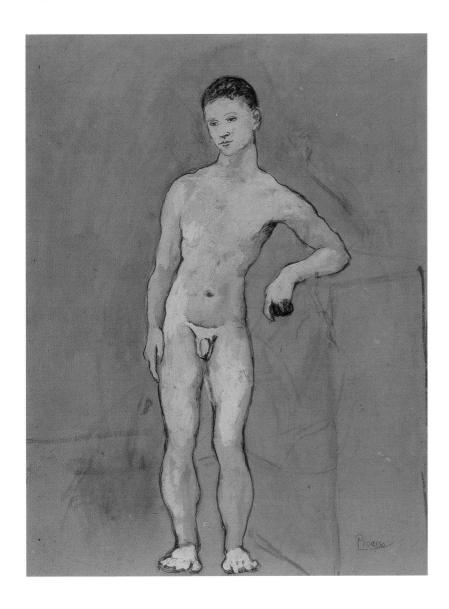

Even though Picasso himself repeatedly insisted on the inner, subjective nature of the Blue Period, its genesis and, especially, the monochromatic blue were for many years explained as merely the results of various aesthetic influences. When, however, after sixty-five years of obscurity, the paintings inspired by the death of his friend Casagemas in the autumn of 1901 saw the light of day, the psychological motive behind the Blue Period seemed to have been discovered. "It was when thinking that Casagemas was dead that I began to paint in blue," Picasso told Daix.⁶

- 23. Family of Acrobats
 with a Monkey, 1905.
 Gouache, watercolours, pastels and
 Chinese ink on cardboard, 104 x 75 cm.
 Göteborgs
 Konstmuseum,
 Göteborg.
- 24. *Naked Boy*, 1905. Tempera on cardboard, 67.5 x 52 cm. The Hermitage, St. Petersburg.

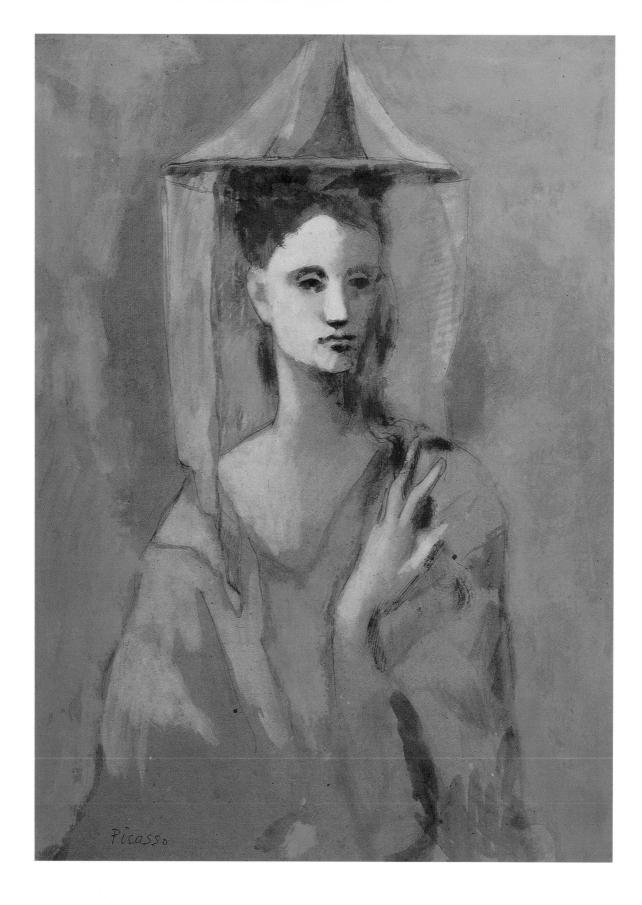

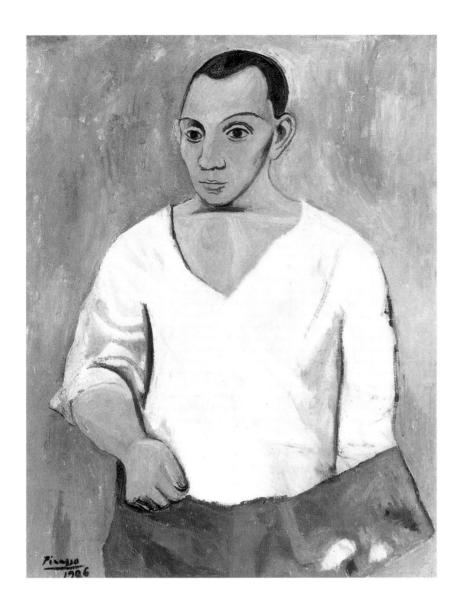

Blue is cold, it is the colour of sorrow, grief, misfortune, inner pain; but blue is also the most spiritual of colours, the colour of space, thoughts and dreams that know no confines. In one of his poems of the 1900s Picasso wrote, "You are the best of what exists in the world. The colour of all colours... the most blue of all the blues." The Blue Period as a whole, throughout its entire three years, resulted in an art that was heterogeneous and complex, not only in style but also in content. The *Portrait of the Poet Sabartés* (p.15), according to Sabartés himself, belongs to the time of the Blue Period's inception; it was created in Paris in October-November 1901.

- 25. Spanish Woman from Majorca, 1905.
 Gouache and water-colours on cardboard, 67 x 51 cm. The Pushkin Museum of Fine Arts, Moscow.
- 26. Self-portrait with a Palette, 1906. Oil on canvas, 92 x 73 cm. Philadelphia Museum of Art, Philadelphia.

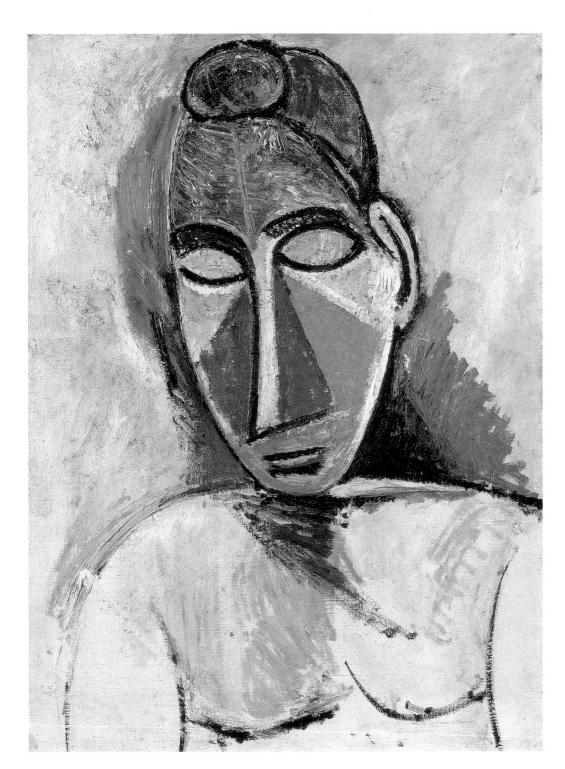

27. *Nude* (*Half-Length*), 1907. Oil on canvas, 61 x 47 cm.
The Hermitage, St. Petersburg.

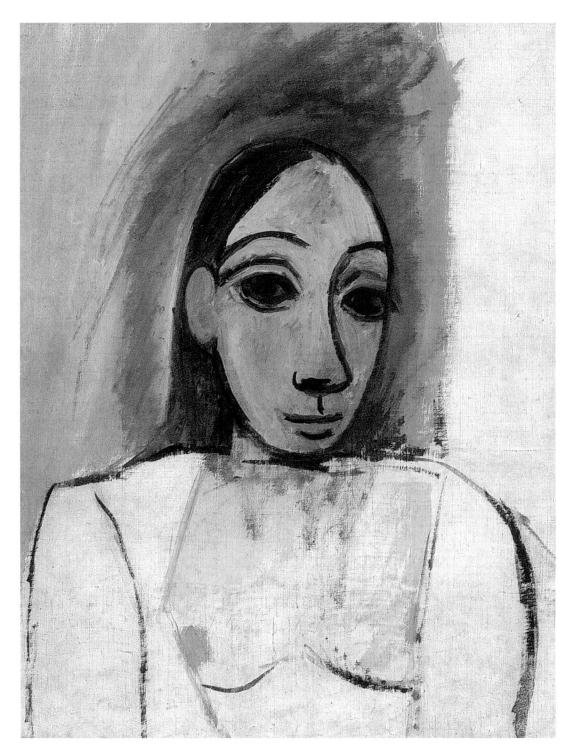

28. Woman (Half-Length), 1906-1907, Study for Les demoiselles d'Avignon. Oil on canvas, 58.5 x 46 cm. Musée Picasso, Paris.

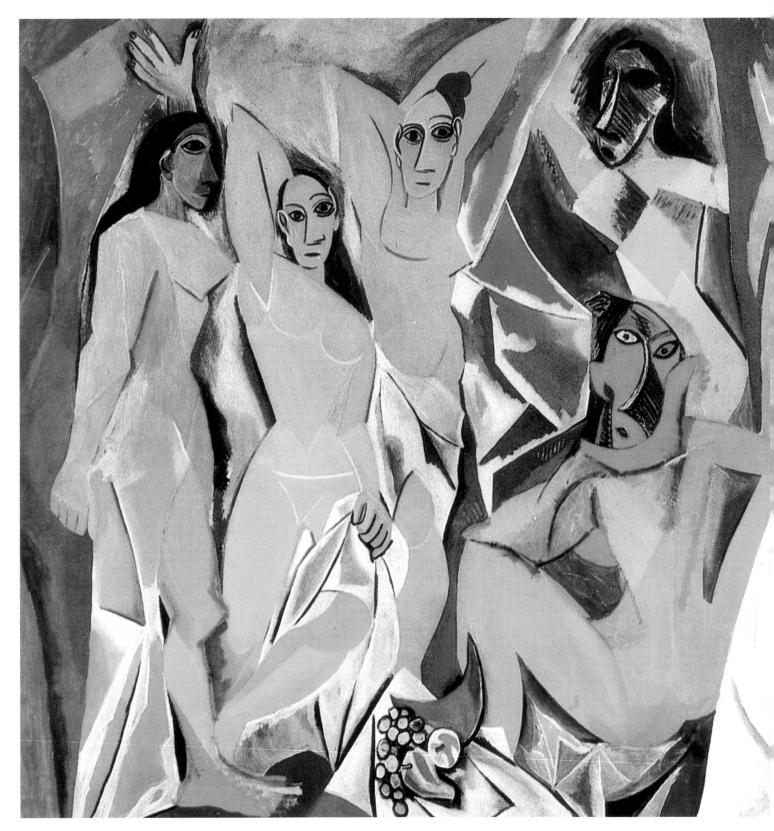

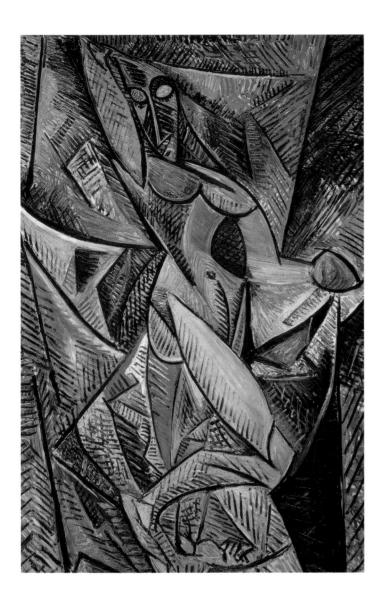

Blue is the picture's actual subject, an expression of the state of mind of the poet. The blue colour is abstract and universal, it makes Sabartés figure, seated at a café table, a symbol of poetic melancholy that looms over the world's empty horizon. Blue is the painting's metaphor for sadness and sorrow; however, towards the end of 1901, the desire to express these feelings more directly motivated Picasso to turn to sculpture. The predominance of form in his paintings, mentioned by Daix, undeniably testifies to this interest; Picasso began to sculpt not only because the medium made his plastic idea more concrete, but also because it corresponded to his need to impose strict limits on himself, to achieve the most ascetic means of expression.

- 29. Les Demoiselles d'Avignon, 1907. Oil on canvas, 243.9 x 233.7 cm. The Museum of Modern Art, New York.
- 30. The Dance of the Veils (Nude with Drapery), 1907.
 Oil on canvas, 150 x 100 cm.
 The Hermitage, St. Petersburg.

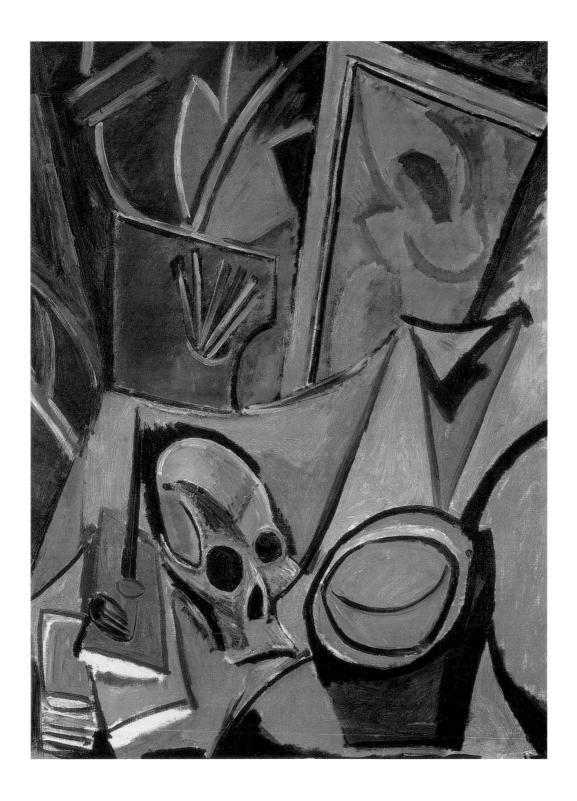

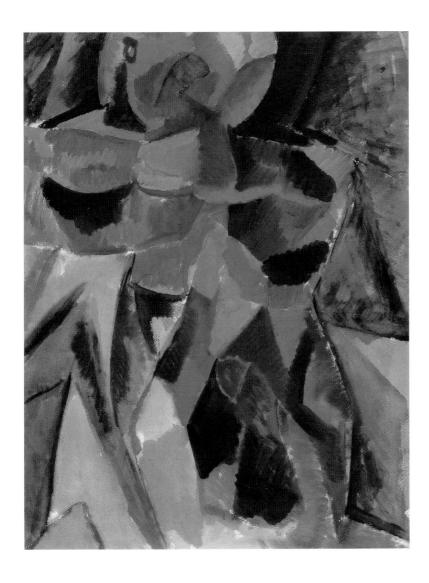

In the painting *The Visit* (p.17), everything pertaining to the depicted event is generalized and frugal. Picasso not only cut back on details, he consciously limited his means of expression to the point of asceticism. The indistinct and simple monochromatic blue corresponds to the composition's elemental quality, the generalized plastic and linear character.

While simplifying the form, Picasso gave the content greater complexity and depth, turning the initial subject into a timeless, universal event - the mournful meeting of two symbolic sisters in another world.

31. Composition with a Skull, 1907. Oil on canvas, 115 x 88 cm. The Hermitage, St. Petersburg.

32. *Friendship*, 1908. Oil on canvas, 152 x 101 cm. The Hermitage, St. Petersburg.

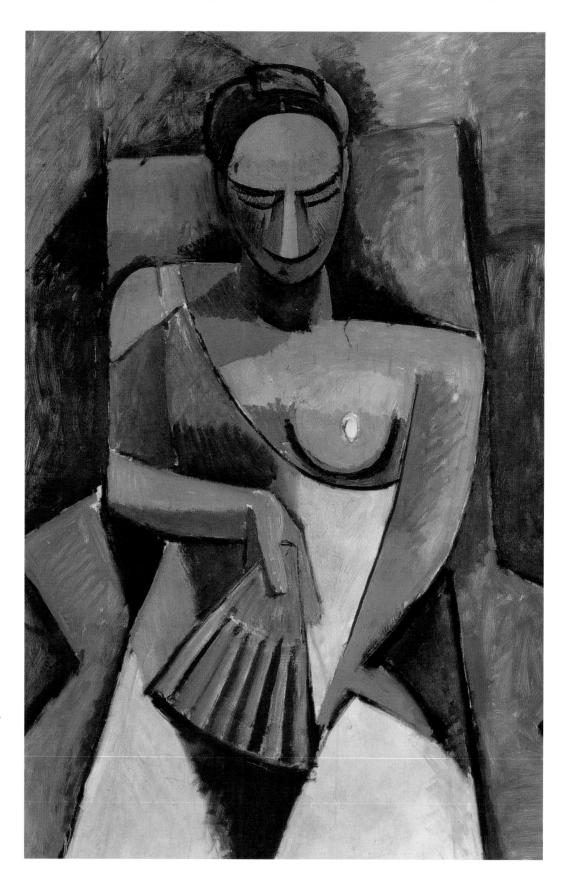

33. Woman with Fan
(After the Ball), 1908.
Oil on canvas,
150 x 100 cm.
The Hermitage,
St. Petersburg.

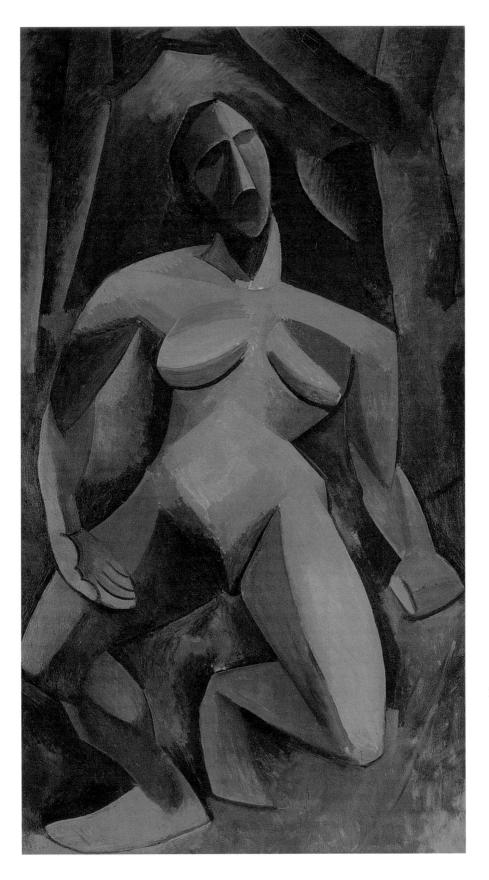

34. *Nude in a Landscape* (*The Dryad*), 1908. Oil on canvas, 185 x 108 cm. The Hermitage, St. Petersburg.

It may well be that in *The Visit* Picasso first discovered for himself the law of the associative and plastic equation of different objects. It would later become an active and important instrument of his poetic imagery, the poetry of metamorphosis, born during the Cubist Period and preserved to the very end.

The Visit, probably completed by the autumn of 1902, is the culmination of the first phase of the Blue Period.

During 1902, three quarters of which Picasso spent in Barcelona, his art strayed far from reality into the area of transcendent ideas expressing only his subjective, spiritual experience. His characters were vague, anonymous, timeless. These are images of ideas. Their visual definition dealing with the plastic modelling of simple forms, the feeling for volume and broad linear rhythms are more typical of a sculptor than of the inspiration of a painter. This was a time when Picasso, as Daix noted, wished to achieve the mélange of form and idea.

The fact that Picasso turned to his first friend in Paris, the poet Max Jacob, for understanding at least in part explains his return in October 1902 to Paris. There they lived in poverty together and after having suffered for three months from cold weather and misery, Picasso left in mid-January 1903.

Yet, as with previous trips, this visit to Paris introduced something new to his art. Not having the means to paint in oil in Paris, Picasso made; thus, when he resumed painting in Barcelona, his new graphic experience manifested itself in his greater attention to the problems of space, of human anatomy, of the tangible features of his characters. In the most significant works of the first half of 1903 – *Poor People on the Seashore (The Tragedy)*(p.21), *Life* (p.24) and *The Embrace* (p.4) – Picasso developed the universal Blue Period themes as scenes of relations between individualized characters.

For his consciousness sought a way out in the external, in reality. This urge for the concrete was expressed in cityscapes and especially in the portraiture which manifested itself in the middle of 1903.

That was when the *Portrait of Soler* (p.18) was created, following a portrait of Soler's wife and a group portrait of the entire family during a summer picnic (p.19): three canvases that work as a triptych. In the unquestionable masterpiece of the autumn of 1903, *Old Jew and a Boy* (p.20), the contact with external reality makes the theme of man's unhappiness concrete by dramatic images of poverty and physical infirmity. Among the paintings of the Blue Period, this is perhaps the most monochromatic and homogeneous in tonality. In *Old Jew and a Boy* the artist interprets the humanistic myth of the nineteenth century, but does it with a Biblical hopelessness for human fate. The painting shows us how Picasso's aesthetic crisis of the "blue years" was to be resolved.

35. *Bathers*, 1908. Oil on canvas, 38 x 62.5 cm. The Hermitage, St. Petersburg.

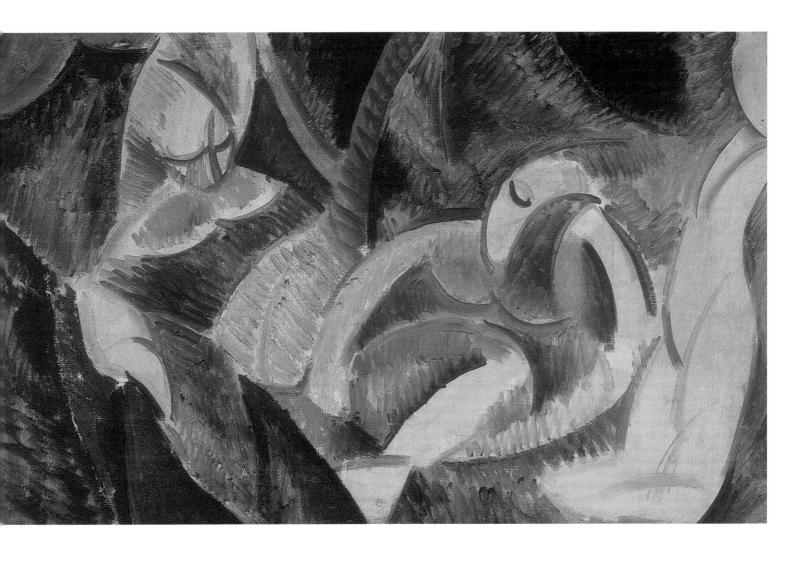

For here the striving to attain extreme expressiveness had necessitated the tangible interplay of lithe plastic forms, the complex linear rhythms, the mimetic contrasts of types, and, finally, the intensely ash-blue colour.

In 1904 the Blue Period, with its pessimistic, ingrown character and furious desire for an aesthetic absolute, reached its climax. This crisis of youth had to be replaced by a new stage in the process of individual development - the stage of self-building. Not accidentally, Picasso now set stock by external conditions, planning another trip to Paris to breathe different air, speak another language, see other faces and adopt another lifestyle.

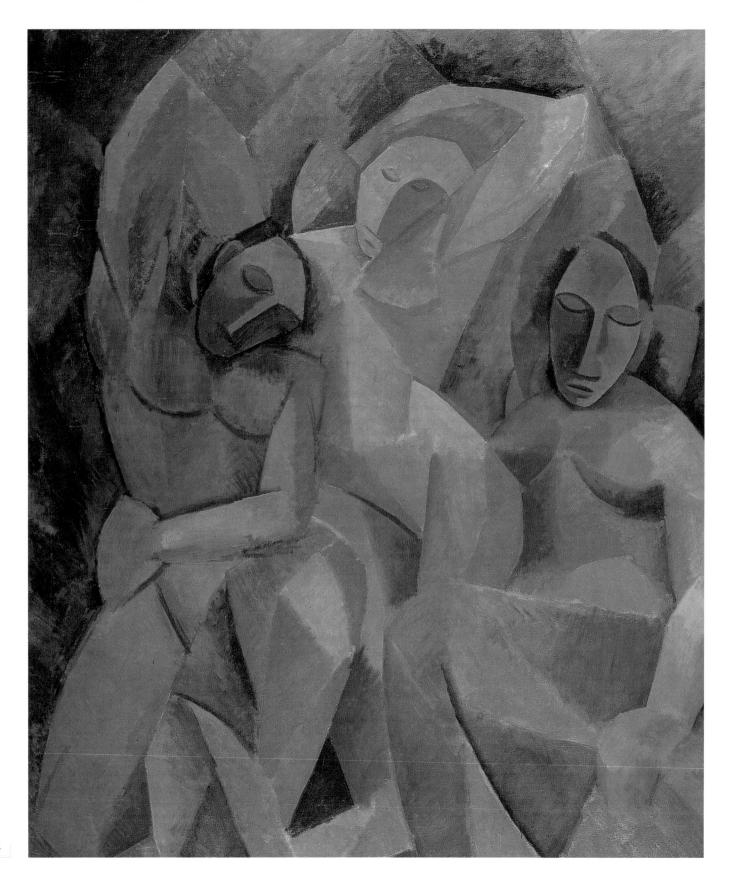

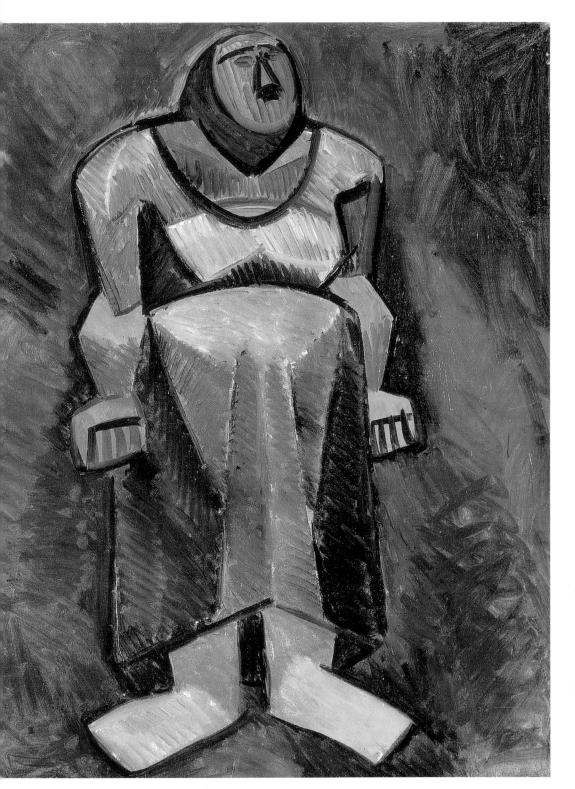

- 36. *Three Women*, 1908. Oil on canvas, 200 x 185 cm. The Hermitage, St. Petersburg.
- 37. *Peasant Woman*(Full-Length), 1908.
 Oil on canvas,
 81 x 56 cm.
 The Hermitage,
 St. Petersburg.

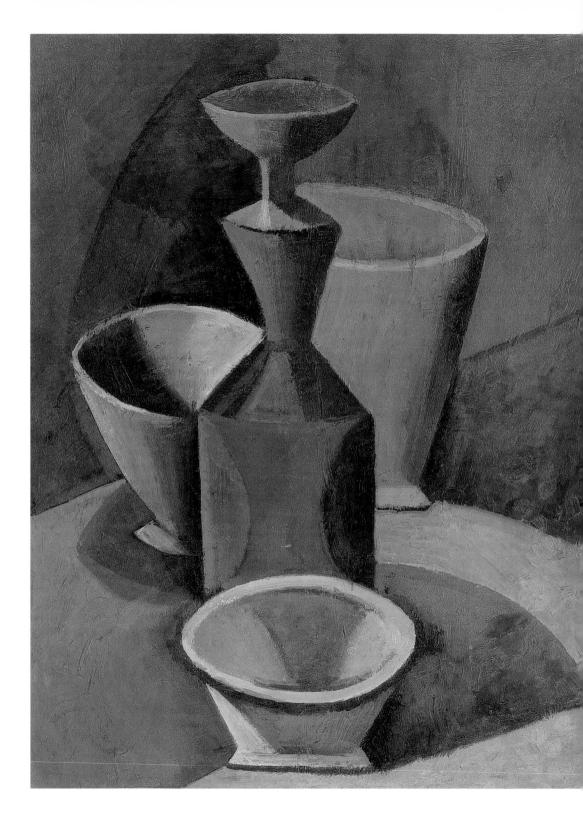

38. *Pitcher and Bowls*, 1908. Oil on cardboard, 66 x 50.5 cm. The Hermitage, St. Petersburg.

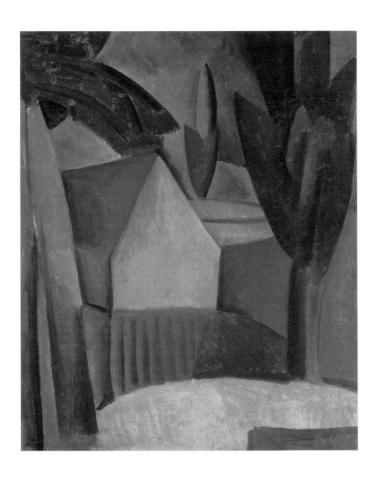

In April 1904 he went back to Paris - for good, as it was to turn out. He moved into a studio building known as the Bateau-Lavoir (Laundry Barge), a nickname given to it by Max Jacob for its strange design. A dilapidated wooden house that clung to the heights of Montmartre, which was pastorally peaceful in those times, the Bateau-Lavoir became Picasso's home for the next five years, and the atmosphere of this bohemian nest, its texture of poverty, became the atmosphere and texture of his canvases of 1904-1908. Picasso's life soon entered family waters, when he met and took up with the beautiful Fernande Olivier. Being with colleagues became less important to Picasso than meeting creative figures from other fields, especially poets, who included André Salmon and Guillaume Apollinaire.

Among Picasso's first Parisian friends were Suzanne Bloch, later a well-known singer, and her brother, the violinist Henri Bloch. In 1904 he gave the couple a photo of himself, executed a brilliant portrait of Suzanne, and presented Henri Bloch with a small canvas, *Head of a Woman with a Scarf* (p.22).

39. House and Trees
(House in a Garden),
1908. Oil on canvas,
73 x 61 cm.
The Hermitage,
St. Petersburg.

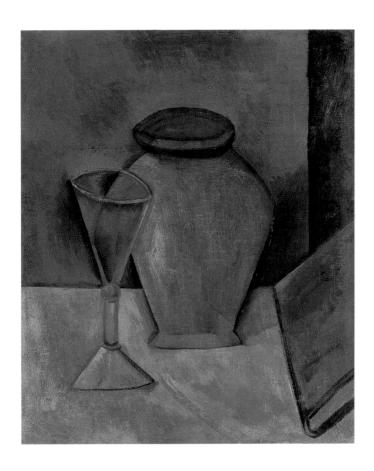

40. *Pot, Wineglass and Book*, 1908. Oil on canvas, 55 x 46 cm. The Hermitage, St. Petersburg.

This work, usually dated to 1903, when Picasso was in Barcelona, is nevertheless more typical of his first Parisian months of 1904, when he used watercolours extensively and worked in the graphic arts. The blue has now been diluted, it is nearly translucent and has red undertones; the drawing is strong and combines attention to detail with expressive stylization. At the same time (and this is characteristic of the end of the Blue Period), the source of the mood is now the individual psychology of the character. The themes began to come from the world of travelling circuses. Picasso perceived the world of the travelling circus as a metaphor for his own environment - the artistic Bohemia of Montmartre, which lived "poorly, but splendidly" (Max Jacob) in feverish excitement and hunger-sharpened sensitivity, in the brotherhood of companionable joviality and the wrenching melancholy of alienation.

This mood of calm, sentimental melancholy was the leitmotif of Picasso's works from late 1904 and the first half of 1905, the so-called Circus or Rose Period.

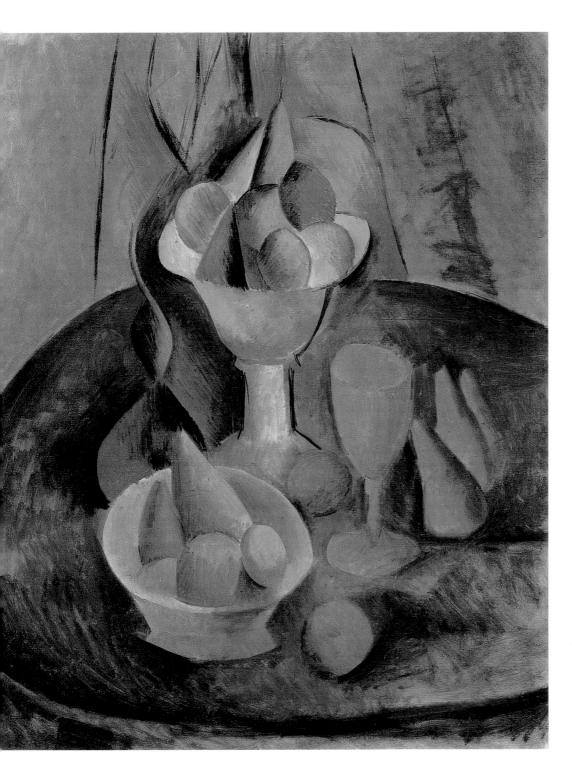

41. Bowl with Fruit and Wineglass (Still Life with Bowl of Fruit), 1908-1909. Oil on canvas, 92 x 72.5 cm. The Hermitage, St. Petersburg.

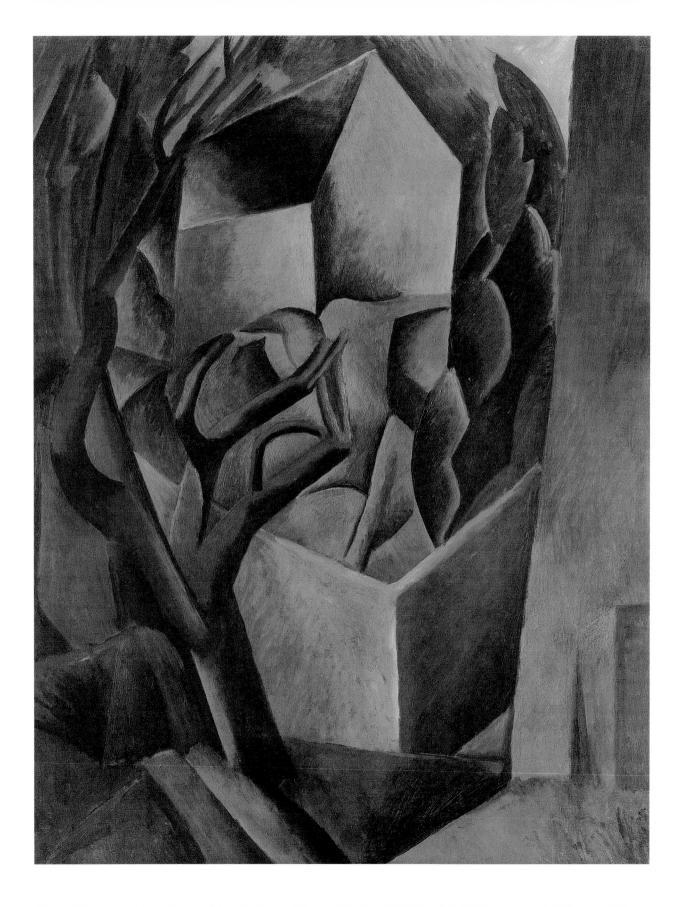

And all the works of that period, including the gouache Boy with a Dog (p.26), are related, some more, some less, to the huge composition on the life of a travelling circus that the artist envisioned at the end of 1904. The chief products of the Circus Period, sometimes also called the Saltimbanque Period, was the Family of Saltimbanques (p.29) created towards the end of 1905. Recent laboratory studies reveal the complex evolution of the painting in both concept and composition. The central motif of the original composition was preserved and rethought in the famous painting Girl on a Ball. Girl on a Ball was painted only a few months after its source, Saltimbanques, and serves as a kind of answer by Picasso to Gauguin's question: "Where do we come from? What are we? Where are we going?" Picasso's original intention was still quite literary. But if, in this painting from the first half of 1905, the issue of form is still in its genesis, its magnitude, complexity and potential can already be sensed. That is why the Girl on a Ball stands out among Picasso's creations as the seed of many further developments in the area of plastic form and imagery. The hieratically mysterious figures of the autumn of 1905 (Spanish Woman from Majorca) were to disappear from his art, while the persistent preoccupation with sources led him to the theme of primal nudity and youthfulness. With the Naked Youth, Picasso wanted to pose the figure like a statue, solidly and weightily, in contrast, as it were, with its relaxed, flowing stance, its displaced centre of gravity and the light tonality dissolving the sharpness of form. But while the youth's naked body recalls a warm, pink Greek marble and the ideal of antique harmony, his solid figure with its large hands and feet is closer to the image of a peasant youth, to those descendants of an ancient Mediterranean race that Picasso would encounter in the summer of 1906 in Gosol, in the Spanish Pyrenees.

His trip to Spain was in itself very significant during that period of returning to his Mediterranean sources; the time spent in Gosol, a tiny mountain village near Andorra, is doubly important, for it shows clearly the sources and the emotions underlying the fascination with archaic Iberian art that so intrigued Picasso in the autumn of 1906 in Paris. Gosol was for Picasso, probably, a second Horta de Ebro, the village where he had spent about a year when he was seventeen. Continuing and delving deeper into the theme of youthful nakedness, Picasso now found his source not so much in the ephebic type, as in the architectonics of simplified plastic forms.

As is evident from *Still Life with Porrón*, the Gosol works reflect a subconscious, but logical, growth of two basic trends in the development of the artist's formal conception: the underlining of the original expressive simplicity of volumes and the increasingly complex compositional structure of the whole.

42. House in a Garden (House and Trees), 1909. Oil on canvas, 92 x 73 cm.
The Pushkin Museum of Fine Arts, Moscow.

These trends would acquire their greatest stylistic expression in Paris during the autumn of 1906 in conjunction with Picasso's discovery of, on the one hand, archaic Iberian sculpture dating from 1000 B.C., recently unearthed by archaeologists and exhibited in the Louvre⁷ in the spring of 1906, and, on the other, the painting of El Greco, which Picasso saw with new eyes as a primarily visionary kind of art. In Gosol, in the summer of 1906 the nude female form assumed an extraordinary importance for Picasso - a depersonalized, aboriginal, simple nakedness, like the concept "woman" (see Two Nudes; Seated Nude with Her Legs Crossed; Standing Nude). From the viewpoint of the artist's internal world, their meaning was undoubtedly far more profound than a simple artistic expression, and that is confirmed by the importance that female nudes were to assume as subjects for Picasso in the next few months: to be precise, in the winter and spring of 1907, when he developed the composition of the large painting that came to be known as Les Demoiselles d'Avignon. Hastily leaving Gosol because of an outbreak of typhus, Picasso returned to Paris with his head shaved bald. Perhaps that led him to depict himself in the famous Self-portrait with a Palette (p.33) from the autumn of 1906 as a juvenile, youthful Adam-the-artist. On 25 October 1906, Picasso turned twenty-five. That date marks the completion of one full cycle in his artistic development. Working in the spring of 1907 on Les Demoiselles d'Avignon (p.36), he was born anew as a painter.

The young artists of the early twentieth century undoubtedly demonstrated an avantgarde spirit of aesthetic radicalism. Yet even the leader of the Fauves, Matisse, was scandalized when he visited Picasso and saw Les Demoiselles d'Avignon; to him the painting was an abuse of modern art, as he could find no aesthetically justified explanation for it. Many of its first viewers, at any rate, saw it as something Assyrian. This was a solitary, internal revolution, and perhaps nobody ever understood it as well as Apollinaire, who went through the same kind of rupture and revolution one year later. What did Picasso gain at the price of forgetting, with such difficulty, his former vision based on classic pictorial tradition? A new understanding of the plastic arts, in which their formal language stands in the same relationship to the forms of the visible world as poetic language stands to everyday speech. Locked up in his studio, working through the night as was his habit, Picasso stubbornly concentrated on learning anew, changing his taste, re-educating his personal feelings. "In those times I worked completely without any models. What I was looking for was something very different," Picasso wrote to Daix.8 He was seeking the power of expression, not in the subject matter, the theme or the object per se, but in the lines, colours, forms, strokes and brushwork taken in their own independent meaning, in the energy of the pictorial handwriting.

43.*Lady with a Fan*, 1909. Oil on canvas, 101 x 81 cm. The Pushkin Museum of Fine Arts, Moscow.

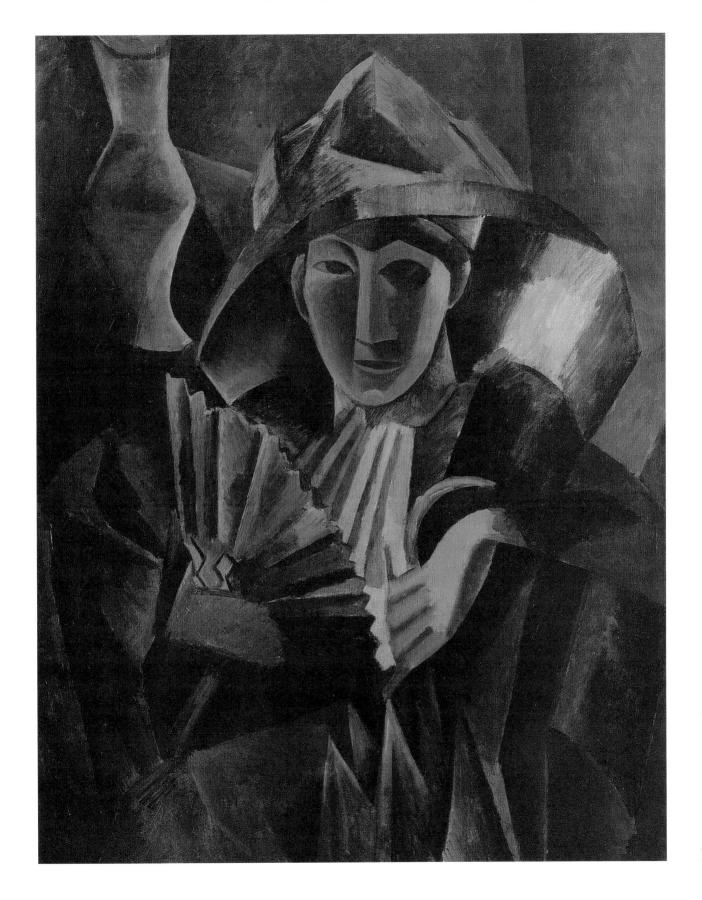

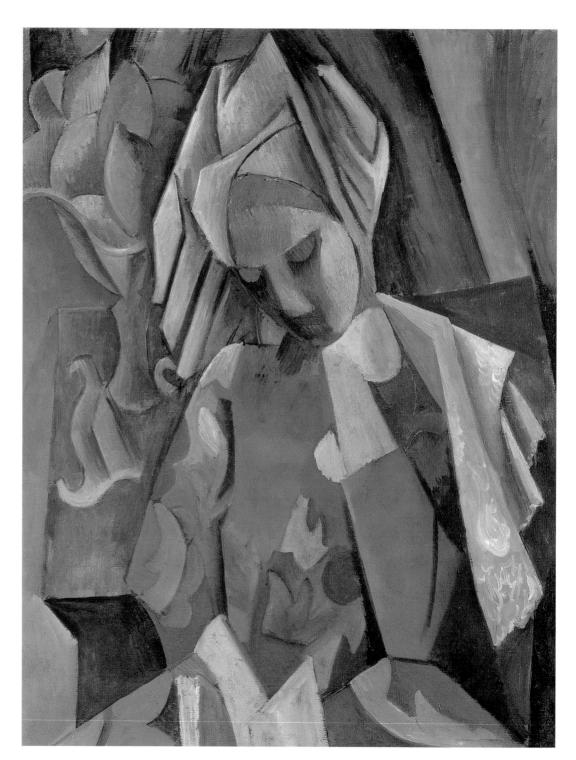

44. *Queen Isabeau*, 1908-1909. Oil on canvas, 92 x 73 cm. The Pushkin Museum of Fine Arts, Moscow.

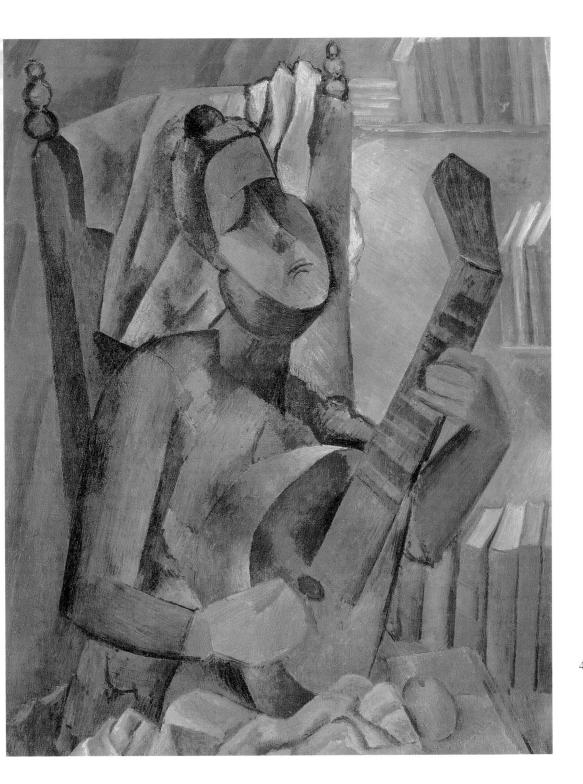

45. Woman with a
Mandolin,
1908-1909. Oil on
canvas, 91 x 72.5 cm.
The Hermitage,
St. Petersburg.

On the one hand, the awkwardness and monstrosity of certain 1907 pictures served to reeducate feeling, while, on the other, they corresponded to Picasso's pictorial philosophy at the time. They both activated his emotional perceptions and imbued the image (thanks to their archaic associations) with a certain timeless atmosphere, a certain eternal background. André Malraux recalls Picasso's words concerning the need "to always work against, even against oneself",9 and that, it seems, was also a discovery of the period. Among the great pictorial revelations of 1907 we find two masterpieces in the Hermitage collection: The Dance of the Veils (Nude with Drapery)(p.37) and Composition with a Skull (p.38). The Dance of the Veils has traditionally - but groundlessly - been regarded in the context of African influences; the entire year of 1907 is referred to as the African period. However, Picasso's "barbarism" of 1907 is not ethnographic in character, it is negativistic; a "working against, even against oneself", as he was to say later. The Dance of the Veils is polemically oriented on the European tradition of painting; it is literally full of various associations with that tradition, more often than not contradicting it. The same link with the European pictorial tradition, if not as simply discernible, is imbedded in the concept of the Composition with a Skull, which is often, and not without reason, interpreted as Picasso's original variation on the Vanitas theme, so widespread in traditional Western painting.

46. *Factory in Horta de Ebro*, 1909. Oil on canvas, 53 x 60 cm. The Hermitage, St. Petersburg.

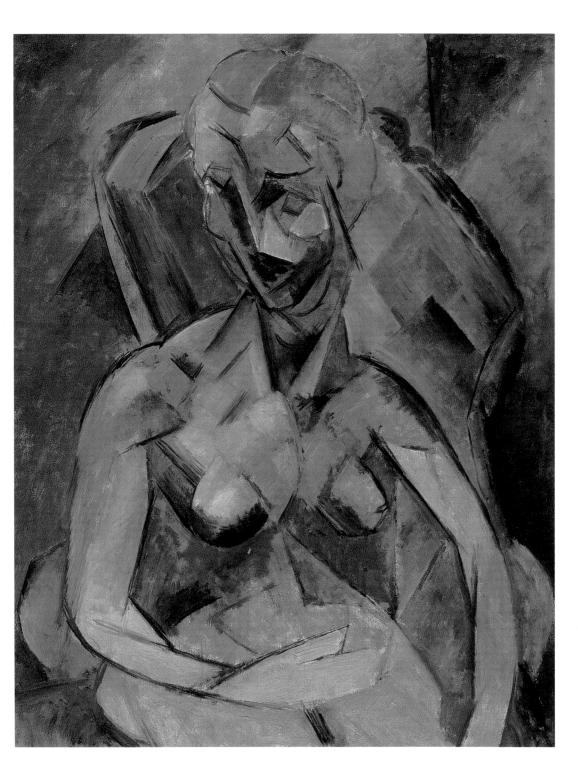

47. Woman Seated in an Armchair, 1909-1910. Oil on canvas, 100 x 73 cm. Musée National d'Art Moderne, CNAC Georges Pompidou, Paris.

It is not sufficient to understand the revolutionary upheaval of 1907 only as a search for untraditional formal approaches to traditional themes in art, only as a renewal of the language of the visual arts. The main achievement of Picasso's creative spirit was the poetic metaphor, that is to say the creation of an image based on the most unexpected associations, on the interplay and power of imagination. The development of this new poetry would, during the Cubist period, lead to such startling inventions as the inclusion of words as images in a visual context.

In spite of the attention paid over the past decade to Picasso's so-called early Cubist work and all the efforts made to achieve some order in the understanding of his evolution, the clarity one would like to see in the general comprehension of the period of 1907-1908 is still lacking. The formal approach, the preconceived view of works of that period as being proto-Cubist or pre-Cubist does not allow scholars to assess the artist in his full significance. Yet it was precisely in 1908, at the height of "proto-Cubism", that visitors to Picasso's studio heard him speak not "of values and volumes", but "of the subjective and of the emotions and instinct".¹⁰

If one leaves aside the concept of proto-Cubism and looks upon the creative material of 1908 as a single entity, ignoring differences in sizes and techniques between paintings, sculpture, and minor sketches, then one sees their organic unity as a monumental ensemble. Turning from the paintings to the original ideas - sketches, drafts, studies - one sees everywhere not simply figurative compositions but, as it were, depictions of certain events, ideas for subjects, each with its own internal dramaturgy.

It seems as though the new form itself - built on the expressive rhythm of strong, sinuous lines, on sharp, clean, articulated planes, on the internal equilibrium of the entire pictorial structure - this morphologically clear and monumentally impressive form - produced in the artist's imagination impersonal, timeless, powerful images.

What could be vaguely felt in the works of 1907 as something existing before time, as some background to eternity, now, thanks to the characteristics of form, becomes objective reality. Deeply involved throughout 1907 in the development of a new plastic anatomy for his painting, an anatomy based on the material of the human figure, Picasso imperceptibly, instinctively uncovers and then grasps the corporal-psychological differences of structure between the male and the female archetype. Basic morphological structure helps him to grasp the metaphorically expressed essential truth of natural phenomena.

The reason for, and meaning of, Picasso's proto-Cubism is normally explained as the artist's desire to radically simplify his pictorial vision of the objective world, to strip away the layers of illusion and reveal its constructive physical essence.

48. *Portrait of Ambroise Vollard*, 1910. Oil on canvas, 93 x 66 cm.
The Pushkin Museum of Fine Arts, Moscow.

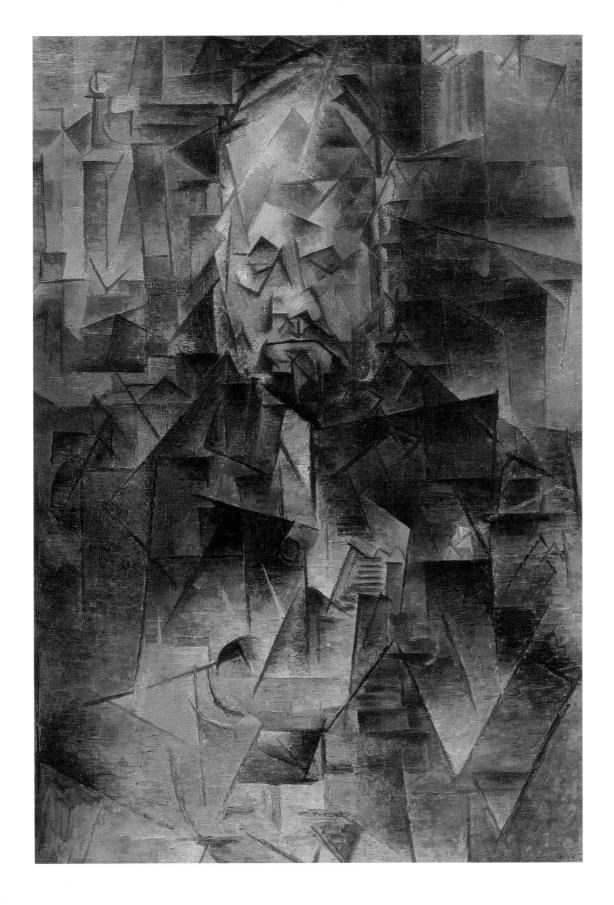

It is usual in this context to cite the famous words Cézanne wrote in a letter addressed to the artist Emile Bernard that was published in the autumn of 1907: "Treat nature by means of cylinder, sphere, cone." Another of the generally assumed points of departure for so-called proto-Cubism is the African influence, which introduced simplification of anatomy and other expressive features. The combination of these two diametrically opposed influences - Cézanne's "perceptualized" art and Africa's "conceptualised" art is usually employed to explain the stylistic phenomenon of proto-Cubism as an art entirely preoccupied with the problem of space.

Yet when we dig deeper into the sources of Picasso's creative ideas - the sketchbooks of early 1908 - we find not objective reality geometrized for geometrization's sake, but rather a desire to lend adequate expression to the artist's subjective truth.

Picasso's proto-Cubism - coming as it did not from the external appearance of events and things, but from great emotional and instinctive feelings, from the most profound layers of the psyche - clairvoyantly arrived at the suprapersonal and thereby borders on the archaic mythological consciousness.

The key work in which both the formal and the pictorial issues of Picasso's proto-Cubism were concentrated was his major canvas of 1908, Three Women (p.44). In that painting, all that remains of the original concept of forest bathers is the general structure of the three-figure group on the right and the colour scheme. Studying these figures, one must not ignore the differences which subtly but unequivocally separate one from the other in spite of their apparent homogeneity. The compositional and conceptual unity and the internal dramaturgy of this strange scene, steeped in torpor, are built on their correlations. Thus, Picasso's interest in reproducing volumes on a flat surface was inseparable in 1908 from sculpture, and it was not before 1909 that the artist came into contact with Cézanne's purely pictorial experience, moving from the colouring of flat planes, inclined this way and that, to the modulation of volume by means of minute, form-creating daubs. The form of Three Women seems to be a sculptor's creation. As for *Peasant Woman* (full-length)(p.45), with its powerfully hewn volumes and mass that seems to be charged with dynamite, it originated directly from work on a carved statue. For Picasso sculpture also served to verify the feeling of reality, in the sense of physical validity, since for him "sculpture is the best comment that a painter can make on painting." In the summer of 1908, Picasso at first turned to the still-life genre because of his depressed state of mind and a desire to find support in the world of simple realities. Later his inquisitive and creative penetration into the specifics of how painting might represent objective realities opened the way to a completely new method of plastic representation, called Cubism.

49. Bottle of Pernod and Wineglass (Table in a Café), 1912. Oil on canvas, 45.5 x 32.5 cm. The Hermitage, St. Petersburg.

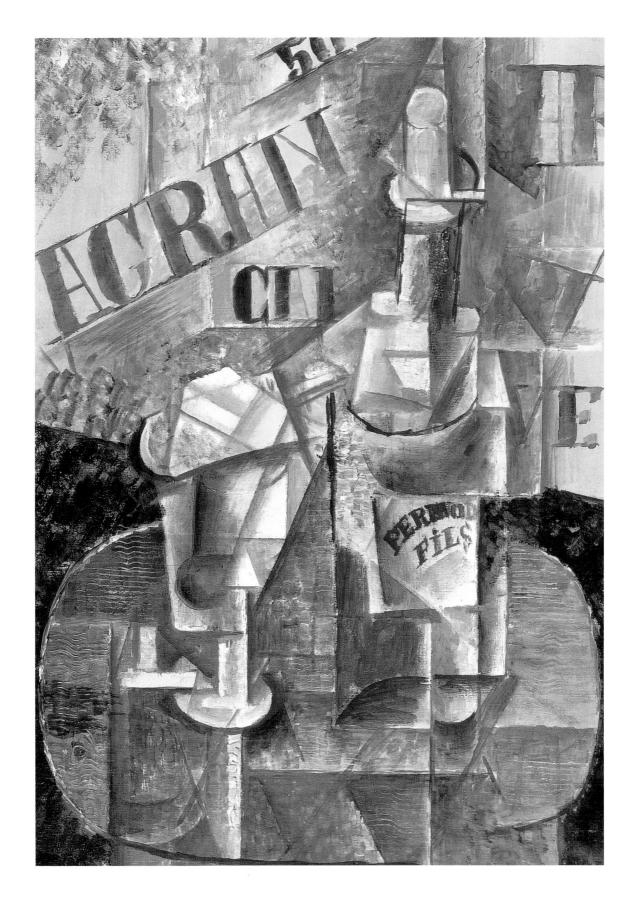

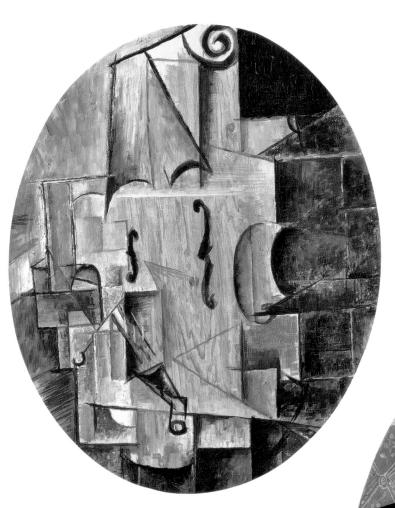

50. *Violin*, 1912. Oil on canvas, 55 x 46 cm.
The Pushkin Museum of Fine Arts, Moscow.

51. *Musical Instruments*, 1913. Ripolin, oil, plaster, sawdust on oilcloth, 98 x 80 cm. The Hermitage, St. Petersburg.

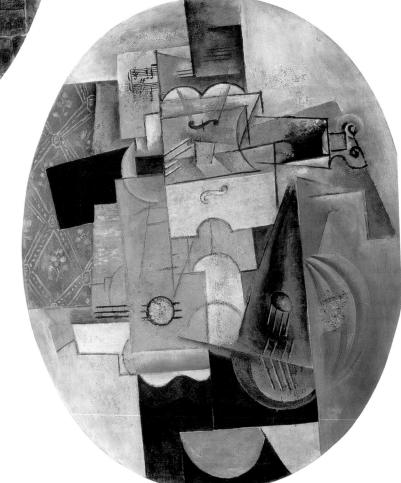

It is not accidental that the still-life genre, with its concrete space, became the favourite subject of Cubist painting. No other genre was so conducive to a concentrated analytical inquiry into the structural principles of the stable forms in a spatial ensemble. The absence of exact dates, which makes it impossible to determine the absolute chronology of Picasso's proto-Cubism, is perhaps most vexatious for the period between his stay in La Rue-des-Bois in August 1908 and his departure for Horta de Ebro at the end of the spring of 1909. When one considers as a whole all that was done over these eight months - that is, everything created on the very threshold of Cubism one sees the artist's thoughts flowing in many directions, some of which led to and synthesized new trends, while others temporarily disappeared below the surface. Having a post factum knowledge of what might be called the ideal goal of this progression, Cubism, scholars observe the accumulation in Picasso's work between the autumn of 1908 and the spring of 1909 of those formal features which mark the "most important and certainly the most complete and radical artistic revolution since the Renaissance". 12 Just as African art is usually considered the factor leading to the development of Picasso's classic aesthetics in 1907, the lessons of Cézanne are perceived as the cornerstone of this new progression.

Georges Braque, with whom Picasso became friends in the autumn of 1908 and together with whom he led Cubism during the six years of its apogee, was amazed by the similarity of Picasso's pictorial experiments to his own; he explained that Cubism's main direction was the materialization of space. His penchant for the pictorial, his discovery of Douanier Rousseau as an example of the primitive consciousness, unspoiled by academic aesthetics, and also the beginning of his friendship with Braque ("It was as if we were married," Picasso said) which ended his creative solitude... All these factors made Picasso more receptive than before to the purely pictorial solution of painters, past and present.

Thus, the Hermitage *Nude in a Landscape* (p.41), coming from a series crucially important to Analytical Cubism, seems to be an answer to Matisse's tendency to transform the figure into a flat, coloured arabesque - an organic part of the ripening decorative grand style. Conversely, Picasso is interested in the figure *per se*, the figure as a bodily apparatus which in itself is a powerful tool of expression, as Tugendhold put it so well. "The goal I proposed myself in making Cubism? To paint and nothing more. And to paint seeking a new expression, divested of useless realism, with a method linked only to my thought - without enslaving myself with objective reality." If the artist spoke of a quest for new expression, it is because that was his professional concern - to find adequate means of expression, an adequate language for the impulses inherent in his thinking.

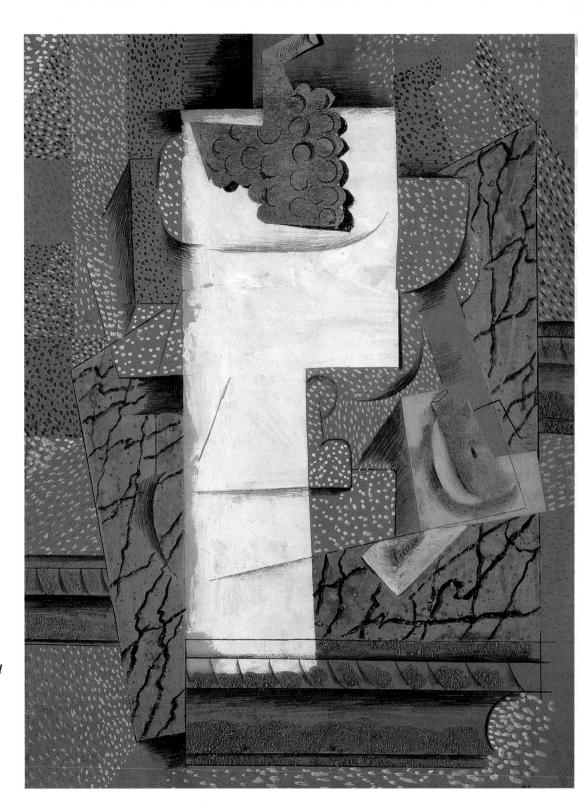

52. Bowl of Fruit with Bunch of Grapes and Sliced Pear, 1914. Paper, gouache, pencil, sawdust on cardboard, 67.6 x 57.2 cm. The Hermitage, St. Petersburg.

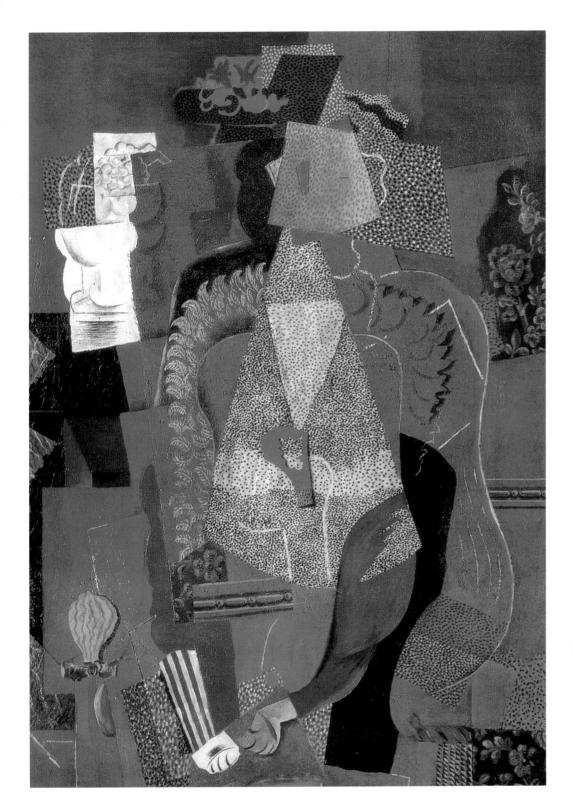

53. Portrait of a Young
Girl (Woman Seated
Before a Fireplace),
1914. Oil on canvas,
130 x 96.5 cm,
Musée National d'Art
Moderne, Centre
Georges Pompidou,
Paris.

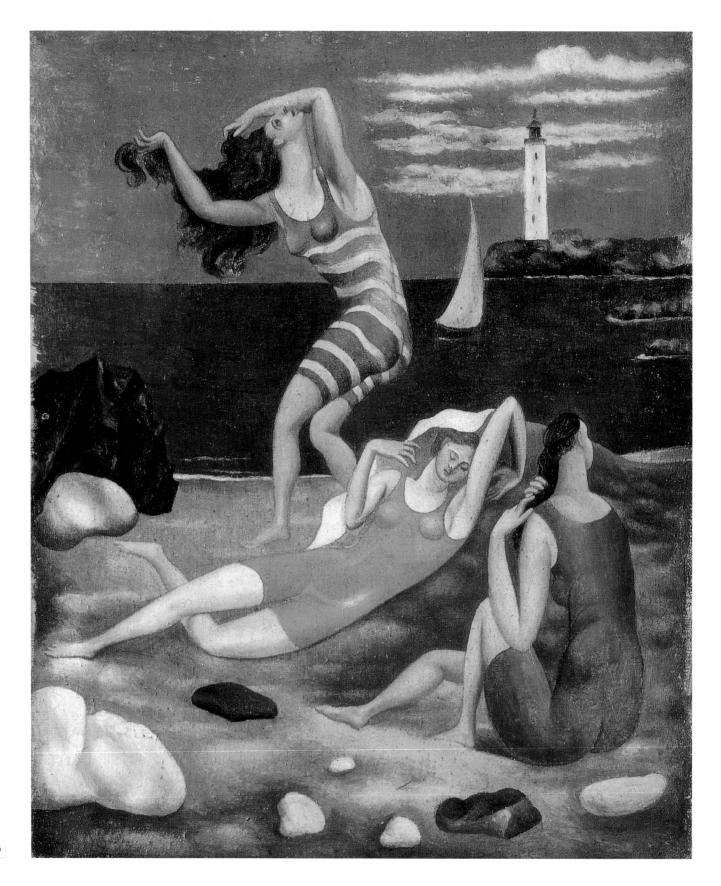

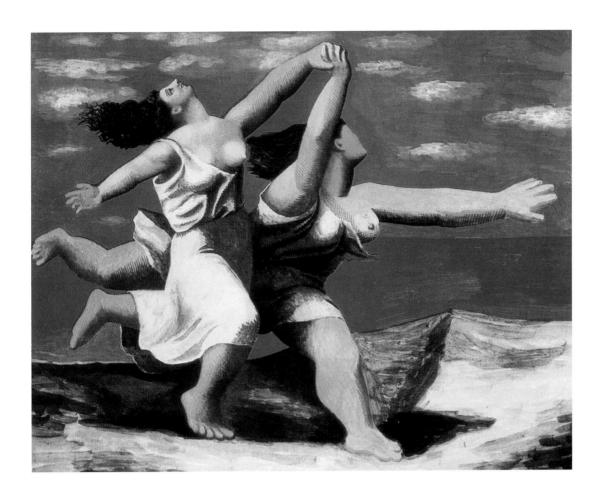

Referring to the transformation of the composition *Carnival at the Bistro* into the still-life *Bread and Bowl of Fruit on a Table*, Pierre Daix believes Picasso "could not have better expressed the thought that, at that stage, every object or character is, above all, a certain spatial rhythm, a three-dimensional structure which plays its role in the composition through what it brings to the pictorial structure of the whole and not through its own reality." Such views, however, are hardly correct, for Picasso at that stage was still very far from abstraction. Never the less, the characteristics of Picasso's objects and figures invariably relate to an internal meaning, as is apparent, for instance, in *Queen Isabeau* (p.54), *Lady with a Fan* (p.53) and also *Woman with a Mandolin* (p.55). In *Woman with a Mandolin* Picasso was on the way to a discovery that would in the future radically transform the very principles of his art - the image presented as a visual metaphor. He stood on the threshold of the discovery of plastic poetry. The evolution of Picasso's Cubism was to assume a certain measure of consistency and logic beginning with the canvases completed after the summer spent at Horta de Ebro in 1909. Such paintings as *Factory* are considered classics of Analytical Cubism.

- 54. *The Bathers*, 1918. Oil on canvas, 26.3 x 21.7 cm. Musée Picasso, Paris.
- 55. Women Running on the Beach, 1922. Gouache on plywood, 32.5 x 42.1 cm. Musée Picasso, Paris.

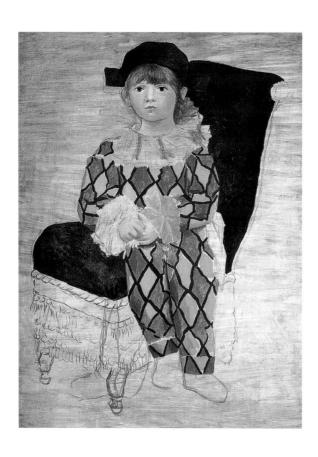

56. *Paul as Harlequin*, 1924. Oil on canvas, 190 x 97.5 cm. Musée Picasso, Paris.

57. *The Sculptor*, 1931. Oil on plywood, 128.5 x 96 cm. Musée Picasso, Paris.

In Horta Picasso felt reality with his entire body, with all his senses, with his very conscience; his art once more made contact with his environment. This contact was, however, affected with the help of his new "optics": they were amazingly purist in their simplicity and clarity. They excluded the accidental, the formless and the secondary; they brought order to nature's chaos and at the same time sharpened to the limit the version of form as the interplay of spatial contrasts, turning a scene into a rich panorama of different aspects arranged according to the character of the subject. They were to serve as the basis of Cubism's formal vocabulary. Generally considered a masterpiece of Analytical Cubism, the Moscow Portrait of Ambroise Vollard (p.59) is a real masterpiece of psychological realism, illuminating a quality that was perceived in 1910 as one of the Spanish painter's paradoxes, when Metzinger noted: "Picasso openly declares himself a realist."14 Throughout 1910 and 1911 Picasso and Braque, shoulder to shoulder, developed this hermetic art in which every picture was an autonomous slice of "pure reality" that did not imitate the environment. And even though these works had their own subjects, usually still lifes and the figures of musicians, the reality of this kind of painting was based on more complex, and not always concrete, feelings.

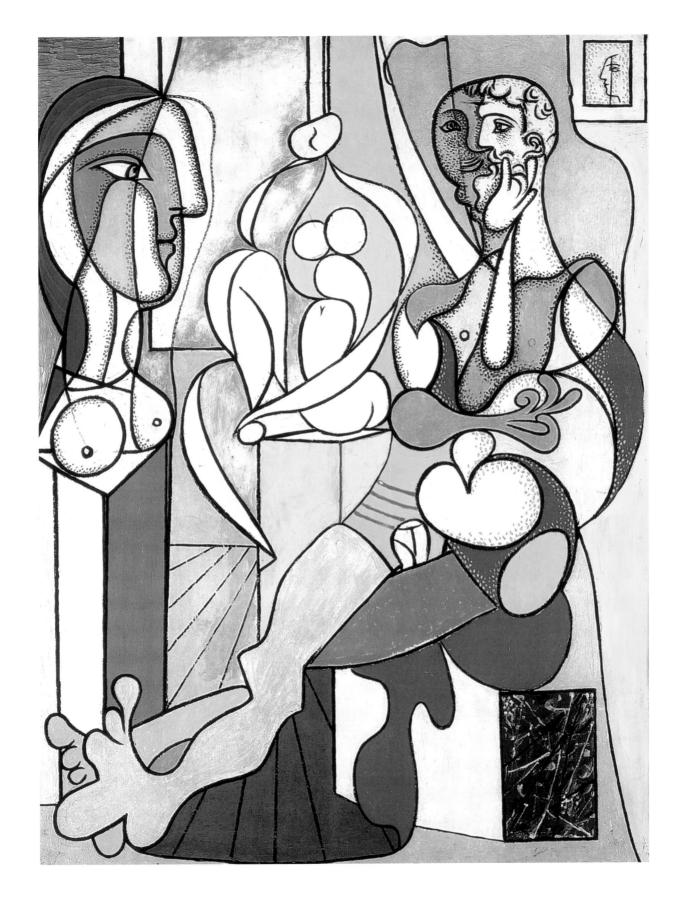

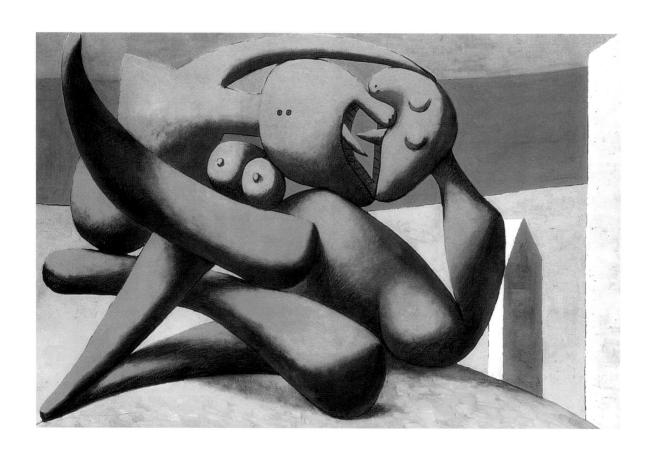

In these hermetic paintings Picasso communicated a "scent" of reality that one can grasp through visual allusions: the contours of a glass, a pipe, the elbow-rest of an armchair, the fringe of a tablecloth, a fan, the neck of a violin. Soon, in the summer of 1911, another kind of allusion from the real world entered Picasso's painting - street signs, newspaper headlines, words from book jackets, wine bottles, and tobacco labels, musical notes - all of which are thematically linked to the subject of the canvas. For Braque and Picasso, letters are flat forms that help create the spatial relations of the picture. They are also elements of the surrounding environment that participate in presenting the theme, supporting its subject, which they enter untransformed. Besides that, words and entire sentences, parts of words and syllables, are, to artists who live in close contact with poets, verbal images assuming meaningful relations with the painting's pictorial realities, giving the image a multiplicity of meanings. This combination of two pictorial levels also leads to the transformation of the picture into a charade with many meanings, a play on words, a total metaphor - an effect that Picasso highly prized. In the painting Table in a Café, created in the spring of 1912, the letters crossing the background behind the still-life are part of advertisements painted on the invisible glass panel of the café window.

58. *Figures on a Beach*, 1931. Oil on canvas, 130 x 195 cm. Musée Picasso, Paris.

They endow the picture with the unmistakable look of modern urban life, while the motif - the bottle of Pernod and the glass with its spoon and cube of sugar, placed on the oval table - reveals Picasso's new taste for a material, concrete environment. During the first half of 1912, Picasso's Cubism underwent a mutation from Analytic to Synthetic. Somewhere at the very start of the year Picasso felt the need to work with tangible forms of reality - to sculpt. At the same time, his introduction into painting of letters and slogans as naked facts of reality opened the way to other facts of reality: in particular, the gluing on of different materials with their own ready-made printed forms, textures, ornaments - and so the collage technique appears. The appearance of reality - so direct and unequivocal - signalled the end of the illusory, hermetic and anonymous style of painting called Analytical Cubism, which Picasso developed for a year and a half in such intimate contact with Braque.

59. *The Lecture*, 1932. Oil on canvas, 130 x 97.5 cm. Musée Picasso, Paris.

The essence of Picasso's creative genius differs from that usually associated with the notion of "artiste-peintre", although, as Picasso himself put it, he "led the life of a painter" from very early childhood, and although he expressed himself through the plastic arts for eighty uninterrupted years, it might be more correct to consider him an artist-poet because his lyricism, his psyche, his gift for the metaphoric transformation of reality are no less inherent in his visual art than they are in the mental imagery of a poet. According to Pierre Daix, "Picasso always considered himself a poet who was more prone to express himself through drawings, paintings and sculptures."15 There is, however, no doubt that from the outset Picasso was always "a painter among poets, a poet among painters". 16 Picasso had a craving for poetry and attracted poets like a magnet. When they first met, Apollinaire was struck by the young Spaniard's unerring ability "to straddle the lexical barrier" and grasp the fine points of recited poetry. One may say without fear of exaggeration that while Picasso's close friendship with the poets Jacob, Apollinaire, Salmon, Cocteau, Reverdy and Eluard left an imprint on each of the major periods of his work, it is no less true that his own innovative work had a strong influence on French twentieth-century poetry. And this assessment of Picasso's art - so visual and obvious, yet at times so blinding, opaque and mysterious - as that of a poet, is dictated by the artist's own view of his work. He even expressed the following thought: "If I had been born Chinese, I would not be a painter but a writer. I'd write my pictures."17 In the summer and autumn of 1912, while living with Eva in the town of Sorgues-sur-l'Ouvèze, Picasso was literally possessed by one subject: some fifteen paintings of that season depict violins and guitars. This was lyrical painting, steeped in emotions relating the shapes of these instruments to the female form and aspiring to create a harmonic and tangible image out of different elements of form, rhythm, texture, both of material and painted surface, and colour. Still Life with Violin is one of Picasso's first and most harmonious works of that period. The painting can hardly be classed as a still life: its formative idea is better expressed by the words tableau-objet, which Picasso himself used. Musical instruments, considered a lyrical subject by Picasso, continued to occupy his imagination for many months. In the autumn of 1912, in Paris, attempting to realize his new vision, he again turned to three-dimensional sculptural forms to create a family of spatial constructions in the shape of guitars.

60. *Weeping Woman*, 1937. Oil on canvas, 60 x 49 cm. Tate Gallery, London. At the end of 1912, these new lyrical objects as well as the oval *tableau-objets*, destined only to hang on walls, furnished the impulse for endless new interpretations and experimentations.

Through these formal inventions, Picasso had put into practice the plastic metaphor within the frame of the painting, broadening the potentialities of art.

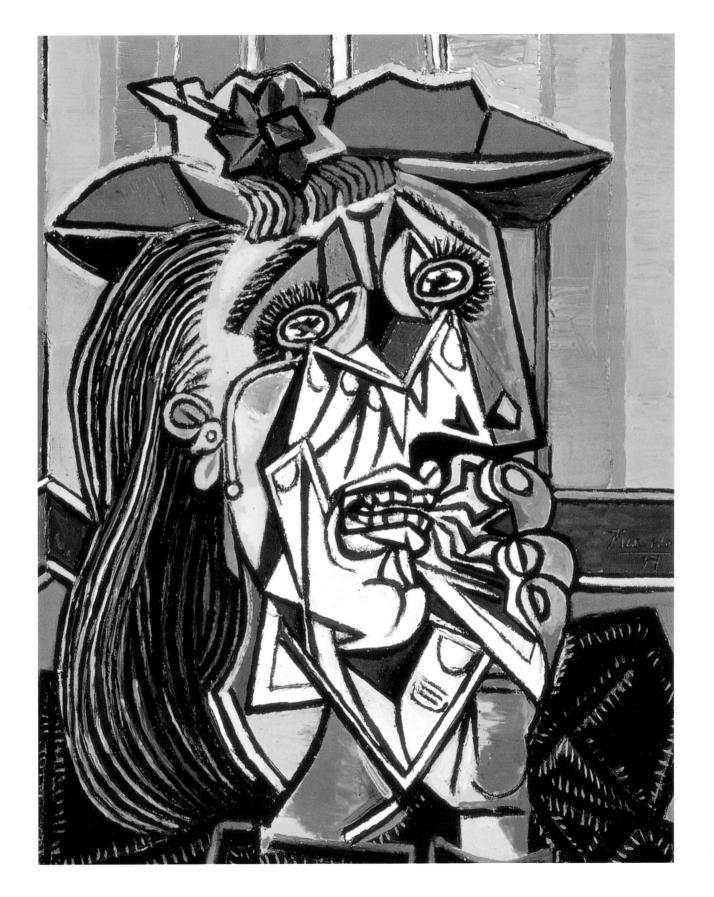

BIOGRAPHY

	1881:	25 October. Birth of Pablo Ruiz Picasso in Málaga. Parents: José Ruiz Blasco, a teacher of drawing at the School of Fine Arts and Crafts and curator of the local
		museum, and Maria Picasso y Lopez.
	1888-89:	The first of little Pablo's paintings, <i>Picador</i> .
	1891:	The Ruiz-Picasso family moves to La Coruña, where Pablo studies drawing and painting under his father.
	1894:	The third year of his studies at the School of Fine Arts in La Coruña. Don José will never paint again.
	1895:	The family moves to Barcelona. In Madrid, at the Prado he discovers Velázquez and Goya. Enrolls at the School of Fine Arts in Barcelona, popularly called "La Lonja". His father rents a studio for him. Paints his first large academic canvas, First Communion.
	1897:	Science and Charity receives honourable mention in the National Exhibition of Fine Arts in Madrid, in June, and later receives a gold medal at Málaga. Picasso is admitted to the Royal Academy of San Fernando in Madrid.
	1898:	Returns to Barcelona in June. Together with Manuel Pallarés goes to Horta de Ebro (renamed Horta de San Juan in 1910) and spends eight months there.
	1899:	In Barcelona joins a group of avant-garde intellectual artists who frequent the café Els Quatre Gats. Modernist tendencies appear in his works. Paints <i>The Last Moments</i> .
	1900:	Leaves for Paris and settles at 49, Rue Gabrielle in Montmartre. His first dealers: Pedro Manach and Berthe Weill. Cabaret and Montparnasse themes. <i>The Last Moments</i> is exhibited at the Paris Exposition Universelle.
	1901:	Publishes the review <i>Arte Joven</i> . Spanish brutalism prevails in the subject matter. Returns to Paris in May; development of pre-Fauvist style (Cabaret Period). Exhibition of sixty-five of his works (24 June-14 July) at the Galerie Vollard. Friendship with Max Jacob. Influenced by Lautrec and Van Gogh. The Casagemas
	1000	death cycle. First Blue paintings.
	1902:	Develops Blue style in Barcelona.
	1904:	In Paris, he moves into the Bateau-Lavoir in Montmartre. End of Blue Period. Takes up engraving. Friendship with Apollinaire and Salmon. Meets Fernande Olivier.
	1905:	Exhibits at Galerie Serrurier.(travelling circus themes) Completes the large canvas Family of Saltimbanques. End of the Circus Period.
	1906:	Rose Classicism. Gertrude Stein introduces Picasso to Matisse. Meets André Derain. Summer in Gosol. That autumn in Paris: paints a self-portrait reflecting Iberian archaic sculpture.
	1907:	Le Demoiselles d'Avignon. That summer visits the ethnographic museum at Palais du Trocadéro, where he discovers for himself African sculpture. Meets Kahnweiler and Georges Braque.
	1908:	Proto-Cubism. The term "Cubism" is born.
	1909:	From May to September works in Horta de Ebro, develops Analytical Cubism. In the autumn leaves the Bateau-Lavoir and moves to 11, Boulevard de Clichy.
	1910:	Travels in summer to Cadaques with Derain. "High" phase of Analytical Cubism. Nine works shown in London, in the <i>Manet and the Post-Impressionists</i> exhibition.
	1912:	Makes his first collage, <i>Still Life with Chair Caning</i> . Transition of Cubism to Synthetic phase. In September moves to a new studio at 242, Boulevard Raspail. First <i>papiers collés</i> and constructions.
	1913:	Death of his father in Barcelona in May.
. <i>Guernica</i> , 1937.	1914:	Rococo Cubism combines with Cubist structures in a foreshadowing of Surrealist methods.
Oil on canvas,		War declared on 2 August. His friends, Braque, Derain and Apollinaire, are mobilized.
349.3 x 776.6 cm.	1915:	"Ingres" portraits. Death of Eva (14 December).
	1917:	Joins the Diaghilev troupe in Rome, works on décor and costumes for the ballet <i>Parade</i>
Museo Nacional		(scenario by J. Cocteau, music by E. Satie). Meets ballerina Olga Khokhlova (1891-1955).
Centro de Arte Reina Sofia, Madrid.	1918:	Wedding of Picasso and Olga (12 July). Death of Apollinaire (9 November). Moves to 23, rue La Boétie.
• 1000		

61. Guernica, 1937. Oil on canvas, 349.3 x 776.6 cm. Museo Nacional

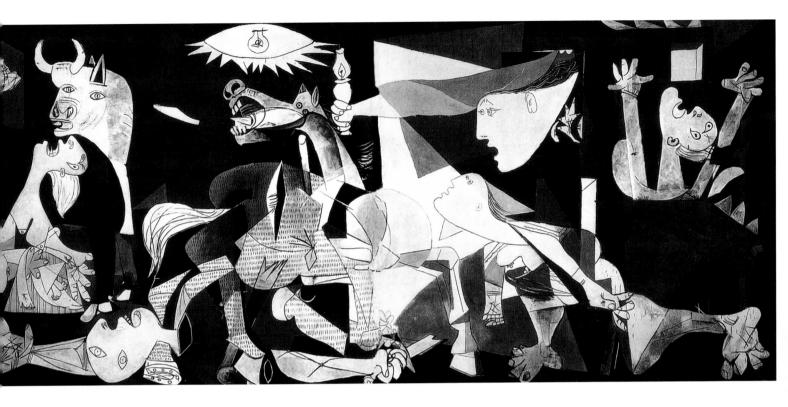

1919: Trip to London (May-August) : design décor and costumes for the ballet *Le Tricorne* (by Manuel de Falla).

1921: Birth of son Paulo (4 February). Continues to work for Diaghilev (*Cuadro Flamenco*). Neo-Classicism.

1925: Works in Monte Carlo for the Ballets Russes. Paints *The Dance*.

1927: In January meets seventeen-year-old Marie-Thérèse Walter. Theme of biomorphic bathers. First etchings for *Le Chef-d'oeuvre Inconnu* by Balzac.

1928: Executes the huge collage *Minotaur*. Studio theme appears in his painting, and welded constructions in sculpture (aided by Julio González).

1930: *Crucifixion* based on Matthias Grünewald's Isenheim Altarpiece. Buys the Château de Boisgeloup, near Gisors. Series of etchings illustrating Ovid's *Metamorphoses*.

Major retrospective (236 works) in Paris and Zurich. Lives and works at Boisgeloup: Biomorphic/ "metamorphic" style. Zervos publishes the first volume of the Picasso *Catalogue Raisonné*.

1933: First issue of the Surrealist magazine *Minotaure*. Bullfight and female toreador themes. Fernande Olivier publishes her memoirs, *Picasso et Ses Amis*. Also published is Bernhard Geiser's *Catalogue Raisonné*.

Engraves *Minotauromachy*. That summer completely abandons painting in favour of writing. Maia, daughter of Picasso and Marie-Thérèse Walter, born (5 October). Jaime Sabartés, a friend of Picasso's Barcelona youth, becomes his companion and secretary.

Friendship with Paul Eluard. Beginning of the Civil War in Spain (18 July); the Republican Government appoints him director of the Prado Museum. Meets Dora Maar (née Markovic), who becomes his mistress. Together they discover the town of Vallauris, a nearby ceramics centre.

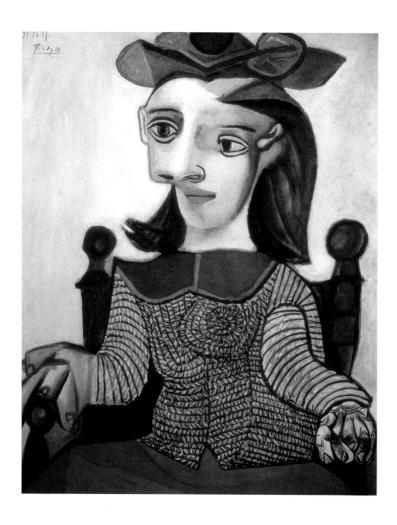

Berggruen, Geneva. soon renamed the Musee Picasso; the themes include fauns, naiads, centaurs.	62. <i>Portrait of Dora</i> Maar, 1939. Oil on canvas, 81 x 65 cm. collection Heinz on 25 August. Opening of Salon d'Automne. Joins the French Communist Party in October. Paints the anti-war <i>The Charnel House</i> . Is attracted to lithography: a portrait of Françoise Gilot. Painting Monument aux Espagnols. Begins living with François Gilot. The Palais Grims	1943: Makes the acquaintance of the young painter Françoise Gilot.	62.	<i>Maar</i> , 1939. Oil on canvas, 81 x 65 cm.	1944: 1945:	Death of Picasso's mother in Barcelona (13 January). Barcelona and Madrid fall. <i>Guernica</i> exhibited in America. Outbreak of World War II finds him in Paris. Leaves Royan, where he stays, on and off, until December. Major retrospective, <i>Picasso: Fo Years of His Art</i> , at the Museum of Modern Art, New York. Works in Royan and Paris. Returns to occupied Paris, refuses financial aid from the Occupation authorities, as well as advice that he had better emigrate to America. Makes the acquaintance of the young painter Françoise Gilot. Max Jacob arrested, dies in Drancy concentration camp (5 March). Paris is liberate on 25 August. Opening of Salon d'Automne. Joins the French Communist Party in October. Paints the anti-war <i>The Charnel House</i> . Is attracted to lithography: a portrait of Françoise Gilot.
Makes the acquaintance of the young painter Françoise Gilot. Max Jacob arrested, dies in Drancy concentration camp (5 March). Paris is liberate on 25 August. Opening of Salon d'Automne. Joins the French Communist Party in October. Paints the anti-war <i>The Charnel House</i> . Is attracted to lithography: a portrait of Françoise Gilot. Painting Monument aux Espagnols. Begins living with François Gilot. The Palais Grima	1943: Makes the acquaintance of the young painter Françoise Gilot.				1940:	Royan, where he stays, on and off, until December. Major retrospective, <i>Picasso: Foyears of His Art</i> , at the Museum of Modern Art, New York. Works in Royan and Paris. Returns to occupied Paris, refuses financial aid from the
Royan, where he stays, on and off, until December. Major retrospective, <i>Picasso: Foyears of His Art</i> , at the Museum of Modern Art, New York. 1940: Works in Royan and Paris. Returns to occupied Paris, refuses financial aid from the Occupation authorities, as well as advice that he had better emigrate to America. Makes the acquaintance of the young painter Françoise Gilot. Max Jacob arrested, dies in Drancy concentration camp (5 March). Paris is liberate on 25 August. Opening of Salon d'Automne. Joins the French Communist Party in October. Paints the anti-war <i>The Charnel House</i> . Is attracted to lithography: a portrait of Françoise Gilot. Painting <i>Monument aux Espagnols</i> . Begins living with François Gilot. The Palais Grima	Royan, where he stays, on and off, until December. Major retrospective, <i>Picasso: F Years of His Art</i> , at the Museum of Modern Art, New York. 1940: Works in Royan and Paris. Returns to occupied Paris, refuses financial aid from th Occupation authorities, as well as advice that he had better emigrate to America. Makes the acquaintance of the young painter Françoise Gilot.	Royan, where he stays, on and off, until December. Major retrospective, <i>Picasso: Fo Years of His Art</i> , at the Museum of Modern Art, New York. 1940: Works in Royan and Paris. Returns to occupied Paris, refuses financial aid from the				Women at Their Toilette. Series of seated women (Dora) and portraits of children (Mai Death of Picasso's mother in Barcelona (13 January). Barcelona and Madrid fall.
Women at Their Toilette. Series of seated women (Dora) and portraits of children (Mai. 1939: Death of Picasso's mother in Barcelona (13 January). Barcelona and Madrid fall. Guernica exhibited in America. Outbreak of World War II finds him in Paris. Leaves Royan, where he stays, on and off, until December. Major retrospective, Picasso: Fo Years of His Art, at the Museum of Modern Art, New York. Works in Royan and Paris. Returns to occupied Paris, refuses financial aid from the Occupation authorities, as well as advice that he had better emigrate to America. Makes the acquaintance of the young painter Françoise Gilot. Max Jacob arrested, dies in Drancy concentration camp (5 March). Paris is liberate on 25 August. Opening of Salon d'Automne. Joins the French Communist Party in October. Paints the anti-war The Charnel House. Is attracted to lithography: a portrait of Françoise Gilot. Painting Monument aux Espagnols. Begins living with François Gilot. The Palais Grimal	Women at Their Toilette. Series of seated women (Dora) and portraits of children (Ma 1939: Death of Picasso's mother in Barcelona (13 January). Barcelona and Madrid fall. Guernica exhibited in America. Outbreak of World War II finds him in Paris. Leaves Royan, where he stays, on and off, until December. Major retrospective, Picasso: F Years of His Art, at the Museum of Modern Art, New York. 1940: Works in Royan and Paris. Returns to occupied Paris, refuses financial aid from th Occupation authorities, as well as advice that he had better emigrate to America. Makes the acquaintance of the young painter Françoise Gilot.	1938: Women at Their Toilette. Series of seated women (Dora) and portraits of children (Mai 1939: Death of Picasso's mother in Barcelona (13 January). Barcelona and Madrid fall. Guernica exhibited in America. Outbreak of World War II finds him in Paris. Leaves Royan, where he stays, on and off, until December. Major retrospective, Picasso: Fo Years of His Art, at the Museum of Modern Art, New York. 1940: Works in Royan and Paris. Returns to occupied Paris, refuses financial aid from the			1937:	

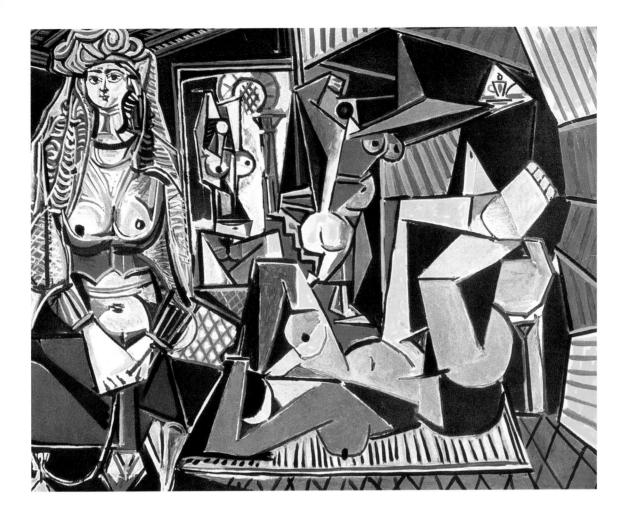

1947: Birth of Claude, first child of Françoise and Picasso (15 May). Takes up ceramics in Vallauris.

1948: Illustrations. Together with Eluard, flies to Wroclaw, Poland, for the Congress of Intellectuals for Peace; receives Commander's Cross with Star of the Order of the Renaissance of the Polish Republic. Exhibits 149 ceramics in November in Paris.

Lithograph of a dove for the poster of the Peace Congress in Paris becomes known as the *Dove of Peace*. Birth of Paloma (19 April), daughter of Picasso and Françoise Gilot.

1950: Awarded the Lenin Peace Prize.

1951: Paints *Massacre in Korea*, exhibited in Salon de Mai, Paris. Most of the time lives in the Midi. works at Vallauris, visits Matisse in Nice.

1953: Major retrospectives in Rome, Milan, Lyons, São Paulo. Separation from Françoise Gilot.

Drawings in Painter and Model series. Portrait of Jacqueline Roque, whom Picasso met a year earlier. They begin to live together. Series of paintings based on Delacroix's *Women of Algiers*.

Major retrospective (150 works) at the Musée des Arts Decoratifs, Paris. Henri-Georges Clouzot's film *Le Mystère Picasso*. Moves with Jacqueline to California, a villa overlooking Cannes.

63. Women of Algiers (After Delacroix), 1955. Oil on canvas, 114 x 146 cm. Collection M. et Mme W. Ganz, New York.

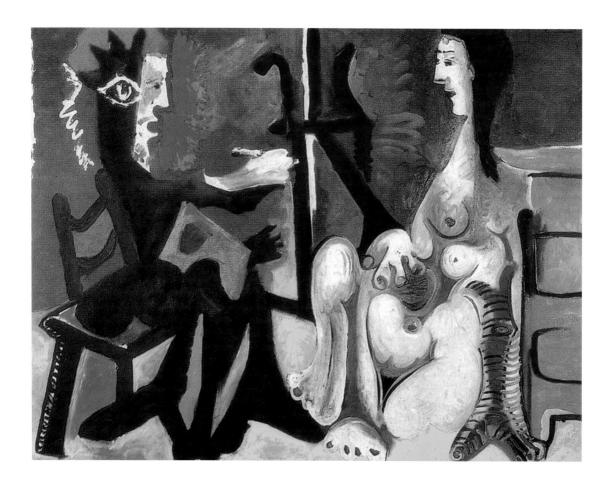

		1956:	Major exhibitions in Moscow and St. Petersburg on the occasion of Picasso's 75th
			birthday.
64.	The Painter and his	1957:	The Maids of Honour (Las Meninas), after Velázquez.
		1959:	Moves to Château de Vauvenargues. Begins long series of works on theme of Manet's
			Déjeuner sur l'Herbe.
	Oil on canvas,	1961:	Wedding of Picasso and Jacqueline Roque. Moves to villa Notre-Dame-de-Vie near
	130 x 162 cm. Museo		Mougins.
	Español de Arte	1962:	Awarded the Lenin Peace Prize.
		1963:	Opening of Museo Picasso in Barcelona.
	Contemporaneo.	1966:	Major retrospective in Paris in honour of 85th birthday.
		1970:	Picasso's relatives in Barcelona donate all paintings and sculptures to Museo Picasso,
65.	Self-Portrait		Barcelona. The Bateau-Lavoir destroyed by fire on 12 May.
	(<i>Head</i>), 1972. Pencil	1971:	Exhibition in the Grand Gallery of the Louvre in honour of Picasso's 90th birthday.
	and crayon on paper,	1972:	Prepares a new exhibition of his most recent works for the Palais des Papes in
	, , ,		Avignon.
	65.7 x 50.5 cm.	1973:	Exhibition of 156 engravings at Galerie Louise Leiris, Paris. 8 April: Picasso dies at
	Tokyo, Fuji		Notre-Dame-de-Vie in Mougins. Buried on 10 April in the grounds of the Château
	Television Gallery.		de Vauvenargues.

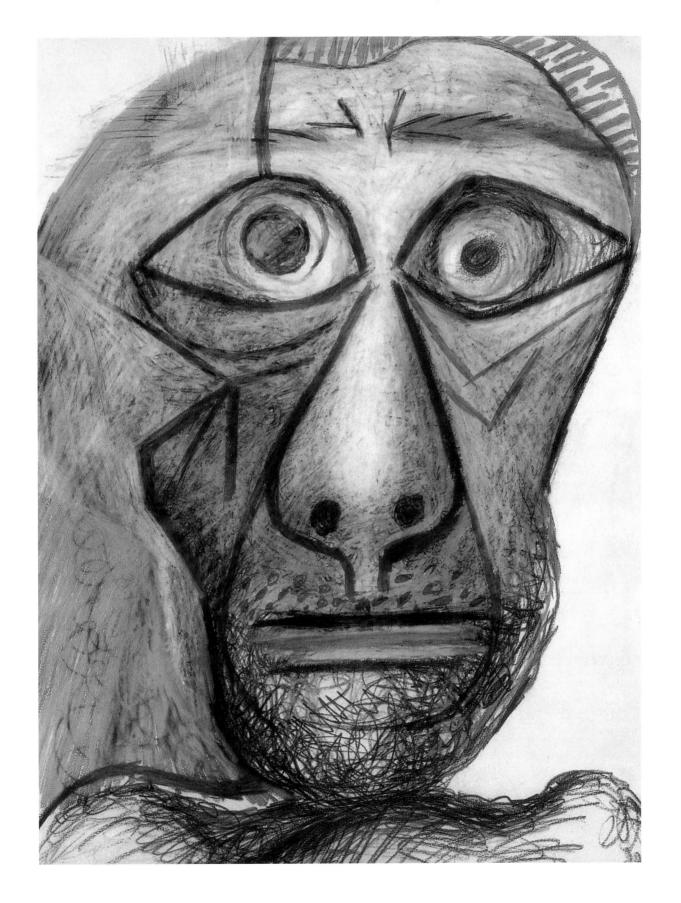

LIST OF ILLUSTRATIONS

1.	The Embrace, 1900.	p.4
2.	Le Moulin de la Galette, 1900.	p.7
3.	Self-Portrait, 1901.	p.8
4.	Harlequin and his Companion, 1901.	p.9
5.	The Absinthe Drinker, 1901.	p.10
6.	The Absinthe Drinker, 1901.	p.11
7.	The Burial of Casagemas, 1901.	p.13
8.	The Burial of Casagemas (Evocation), 1901.	p.14
9.	Portrait of the Poet Sabartés (The Glass of Beer), 1901.	p.15
10.	Self-Portrait, 1901.	p.16
11.	The Visit (Two Sisters), 1902.	p.17
12.	Portrait of Soler, 1903.	p.18
13.	The Soler's, 1903.	p.19
14.	Old Jew and a Boy, 1903.	p.20
15.	Poor people on the Seashore (The Tragedy), 1903.	p.21
16.	Head of a Woman with a Scarf, 1903.	p.22
17.	Life, 1903.	p.23
18.	Celestina, 1904.	p.24
19.	Boy with a Dog, 1905.	p.26
	Tumblers (Mother and Son), 1905.	p.27
21.	Young Acrobat on a Ball, 1905.	p.28
	Family of Saltimbanques (Comedians), 1905.	p.29
	Family of Acrobates with a Monkey, 1905.	p.30
	Naked Boy, 1905.	p.31
	Spanish Woman from Majorca, 1905.	p.32
	Self-portrait with a Palette, 1906.	p.33
	Nude (Half-Length), 1907.	p.34
	Woman (Half-Length), 1906-1907.	p.35
	Les Demoiselles d'Avignon, 1907.	p.36
	The Dance of the Veils (Nude with Drapery), 1907.	p.37
31.	Composition with a Skull, 1907.	p.38
	Friendship, 1908.	p.39
	Woman with Fan (After the Ball), 1908.	p.40
	Nude in a Landscape (The Dryad),1908.	p.41
	Bathers, 1908.	p.43
	Three Women, 1908.	p.44
	Peasant Woman (Full-Length), 1908.	p.45
	Pitcher and Bowls, 1908.	p.46
	House and Trees (House in a Garden), 1908.	p.47
	Pot, Wineglass and Book, 1908.	p.48
41.	Bowl with Fruit and Wineglass, 1908-1909.	p.49
	House in a Garden (House and Trees), 1909.	p.50
	Lady with a Fan, 1909.	p.53
	Queen Isabeau, 1908-1909.	p.54
	Woman with a Mandolin, 1908-1909.	p.55
	Factory in Horta de Ebro, 1909.	p.56
	Woman Seated in an Armchair, 1909-1910.	p.57
	Portrait of Ambroise Vollard, 1910.	p.59
	Bottle of Pernod and Wineglass (Table in a Café), 1912.	p.61
	Violin, 1912.	p.62
	Musical Instruments, 1913.	p.62
	Bowl of Fruit with Bunch of Grapes and Sliced Pear, 1914.	

53.	Portrait of a Young Girl, 1914.	p.65
54.	The Bathers, 1918.	p.66
55.	Women Running on the Beach, 1922.	p.67
56.	Paul as Harlequin, 1924.	p.68
57.	The Sculptor, 1931.	p.69
58.	Figures on a Beach, 1931.	p.70
59.	The Lecture, 1932.	p.71
60.	Weeping Woman, 1937.	p.73
61.	Guernica, 1937.	p.75
62.	Portrait of Dora Maar, 1939.	p.76
63.	Women of Algiers (After Delacroix), 1955.	p.77
64.	The Painter and his Model, 1963.	p.78
65.	Self-Portrait (Head),1972.	p.79

NOTES

- D.-H. Kahnweiler, «Introduction: A Free Man» in *Picasso in Retrospect*, Icon, 1980, p 1.
- ² D.H. Kahnweiler, «Huit entretiens avec Picasso», *Le Point* (Souillac), 7 October 1952, No. 42, p 29.
- ³ R. Penrose, *Picasso: His Life and Work*, London, 1958, p. 50. This statement was familiar to many people with whom Picasso conversed.
- ⁴ A Picasso Anthology: Documents, Criticism, Reminiscences, ed. M. McCully, Princeton, New Jersey, 1982, p. 28.
- ⁵ R. Penrose, Picasso: His Life and Work, p. 74.
- ⁶ P. Daix, La Vie de peintre de Pablo Picasso, p. 51.
- ⁷ In the late 1920s or early 1930s, Picasso himself called Zervos's attention to this 1906 passion of his, which was first analysed and assessed in J. J. Sweeney's article «Picasso and Iberian Sculpture», *The Art Bulletin*, September 1941, pp. 191-198.
- ⁸ P. Daix, «Il n'y a pas 'd'art nègre' dans *Les Demoiselles* d'Avignon», Gazette des Beaux-Arts, October 1970, p. 267.
- 9 A. Malraux, La Tête d'obsidienne, Paris, 1974, p. 131.
- G. Burgess, «The Wild Men of Paris», *The Architectural Record*, New York, XXVII, May 1910, pp. 400-414.
- D. Ashton, *Picasso on Art, A Selection of Views*, New York, 1972, p. 116.
- ¹² J. Golding, *Cubism: A History and an Analysis*, 1907–1914, Boston, Mass., 1968, p. 15.
- ¹³ P. Daix, La Vie de peintre de Pablo Picasso, pp. 102, 103.
- ¹⁴ J. Golding, *Cubism: A History and an Analysis. 1907-1914*, p. 88; E. Fry, *op. cit.*, p. 60 (first published in J Metzinger, "Note sur la peinture", *Pan*, October-November 1910, pp. 649-651).
- ¹⁵ P. Daix, «Eluard et Picasso», in: *Paul Eluard et ses amis peintres*, Paris, 1982, p. 25.
- 16 J. Sabartés, W. Boeck, Picasso, Paris, 1956, p. 36.
- ¹⁷ D. Ashton, *Picasso on Art, A Selection of Views,* New York, 1972, p. 131.